Published in Great Britain in 2013 by Shire Publications
Ltd, PO Box 883, Oxford, OX1 9PL, United Kingdom.

PO Box 3985, New York, NY 10185-3985, USA.

E-mail: shire@shirebooks.co.uk www.shirebooks.co.uk

© 2013 Kiri Bloom Walden.

A CIP catalogue record for this book is available from the
British Library.

Shire Library no. 763. ISBN-13: 978 0 74781 284 5

Kiri Bloom Walden has asserted her right under the
Copyright, Designs and Patents Act, 1988, to be identified
as the author of this book.

Designed by Tony Truscott Designs, Sussex, UK
and typeset in Perpetua and Gill Sans.

Printed in China through Worldprint Ltd.

13 14 15 16 17 10 9 8 7 6 5 4 3 2 1

COVER IMAGE
On the set of *Carry On up the Jungle* (1970), Director
Gerald Thomas talks through the script with his stars,
Frankie Howerd and Sid James. This was the nineteenth
Carry On film and it was shot at Pinewood Studio.
(courtesy of ITV/Rex Features [Peter Rogers
Productions/The Rank Organisation])

TITLE PAGE IMAGE
The Mummy's Shroud (1967) was one of a series of films
made after Hammer entered into an agreement with
Universal Films, that allowed them to remake classics
using stories and characters from the Universal
horror archive.

AUTHOR'S NOTE
Since the late Victorian period, many, many British studios
have existed — some for decades, others for just a few
years. This book is not a comprehensive study of all the
British film studios, but is an introduction to the subject;
the studios that are covered were chosen because they are
representative of the wider industry. These studios either
still exist today or have closed having made a unique
contribution to the industry — but that is not to say that the
smaller studios I have been unable to include have not also
had a part to play. I have concentrated on the film industry
— but it is worth noting that some film studios continued
to exist as television studios long after their time in the
film industry had ended. For further information about all
the British studios, both those mentioned and those not
included, please see the Further Information section at the
end of this book.

Shire Publications is supporting the Woodland Trust, the UK's leading woodland conservation charity, by funding the dedication of trees.

CONTENTS

BRITAIN AND EARLY FILM 4

GAINSBOROUGH:
FROM HITCHCOCK TO MELODRAMAS 14

DENHAM: KORDA'S DREAM 28

PINEWOOD 36

EALING: COMEDIES 50

SHEPPERTON 60

ELSTREE: A BRITISH HOLLYWOOD 76

BRAY: HAMMER HORROR 90

ONWARDS AND UPWARDS 100

FURTHER INFORMATION 109

ACKNOWLEDGEMENTS 110

INDEX 111

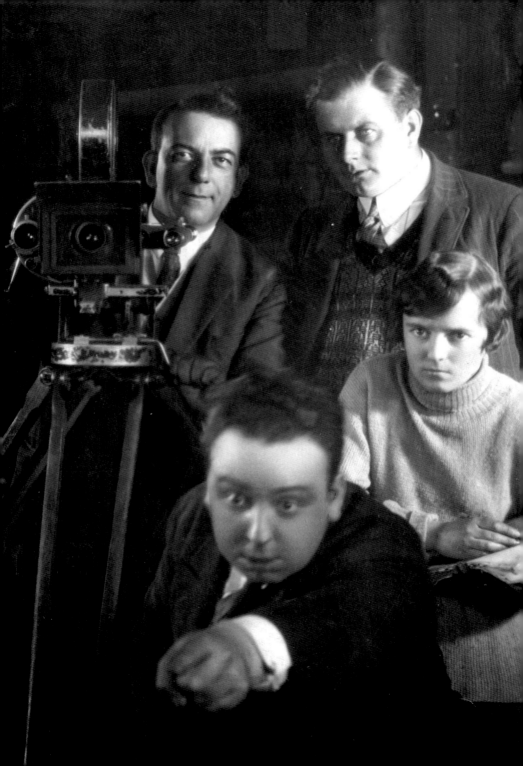

BRITAIN AND EARLY FILM

IN THE EARLY DAYS of film-making, the tiny, forgotten studios of Victorian and Edwardian Britain were cinematic pioneers. By the time the first Hollywood film studio was built in 1911, British studios, founded by a handful of brave entrepreneurs and scattered around the country, were already well established and Britain took a key role in the early development of studio film-making.

In the early days of film, a 'studio' was often just an open-air stage erected in a garden, where someone with enough money to buy a camera and some film stock could turn out the unsophisticated short films proving popular at the time. With a single static camera, the set resembled a stage set, with painted flats as scenery and a single camera position. When studio design developed one step further, these outdoor stages were boxed in to become 'glasshouse' studios – stages enclosed in conservatory-like glass walls. These were more expensive to build, and were fewer in number.

Changes in film-making technology again dictated a change in studio design when glasshouses – which allowed film-makers to use as much daylight as possible – were replaced by 'dark stages' as artificial lighting became the norm. Once again, small studios became obsolete if they could not afford to update the structure with adequate blackout to keep out the daylight that had once been a vital requirement.

It could be said that the history of British film studios started in 1896 when Cecil Hepworth leased a house in Walton-on-Thames. Here he installed electric lighting and set up one of the first film laboratories in the country. Hepworth and his cousin Monty Wicks built a 15 × 18-foot stage in the back garden and started making short films. By 1901 the extended studios were producing over a hundred shorts a year. Hepworth produced *Alice in Wonderland* in 1903 – the largest such project that had been attempted at the time. In 1905 Hepworth built a large glass studio adjoining the original house. With the facilities to print, develop and dry film on site, Hepworth was able to process all his own film. He even had a mechanics' workshop.

Opposite:
Alfred Hitchcock, with his future wife Alma sitting behind him, directs *The Mountain Eagle* for Gainsborough in 1926.

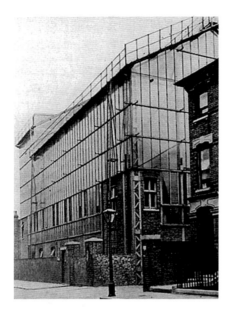

Hepworth's best-known film, *Rescued by Rover*, was produced in 1905. Having led the way with his studio facilities in the early 1900s Hepworth, like many others, unfortunately became a casualty of changing technology. He was unable to keep up with the pace of change and by the early 1920s was declared bankrupt. (Hepworth's studio was purchased by Archibald Nettlefold and as Nettlefold Studios did not shut until 1961).

Hepworth was succeeded by Robert W. Paul soon afterwards. Paul's studio, known as Newton Avenue Works, was built in Southgate in 1899. There Paul built a glasshouse enclosing a stage measuring 28 × 14.6 feet, which featured a suspended floor to allow for theatre-type trapdoors and tricks. A bridge over the stage enabled actors to be suspended above the stage for flying effects. Paul was a clear-headed businessman and he would make two or three short films a week, renting the studio out to other film-makers when he was not using it.

Above: Like other early studios, Lime Grove was built as a glasshouse studio to maximise natural light.

Unlike later studios, early development was not solely concentrated around London and the Home Counties. Little studios were scattered across the country, wherever entrepreneurs and innovators had the imagination and capital to build them. Bradford, Glasgow, Blackburn and Brighton all

Right: *Alice in Wonderland* was made in 1903 by Cecil Hepworth. It used many early special effects and was originally colour tinted.

Opposite, top: *Rescued by Rover* is another Hepworth film, made in 1905. It starred his own child and family dog.

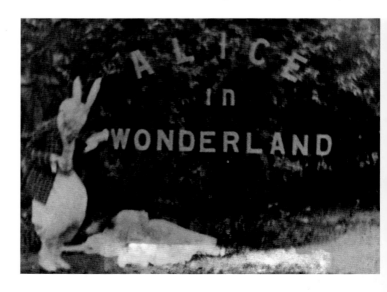

had studios and it has often been regretted that this diverse range of regional studios for the most part failed to survive far beyond the Edwardian boom.

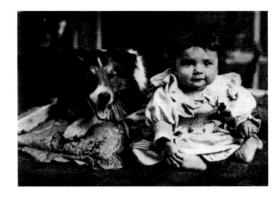

Brighton was an important location for early production and various studios were built around Brighton and Hove between the late 1890s and the early 1900s. George Albert Smith developed his own camera and a basic, two-colour film process, which he called Kinemacolor. He also experimented with editing and camera movement – trying to move away from the static camera position used by so many at that time. Just a short distance away in Hove, James Williamson was making dramatic films that often used special effects (such as reversing the film, using double exposures and superimposition): these films included *Fire* and *Stop Thief!* Williamson's masterly use of editing to heighten dramatic effect was copied by many subsequent film-makers.

The early British film-makers came to the business from many other trades. In Brighton George Albert Smith gave up his stills photography career to move into film. In Bushey renowned painter Sir Hubert von Herkomer founded Bushey Studios and in Cricklewood theatrical impresario Sir Oswald Stoll founded his own studio. Cricklewood (founded in 1919)

Below: Cecil Hepworth in a car with a camera mounted on it. Like many early film-makers, Hepworth filmed both in his studio and on location.

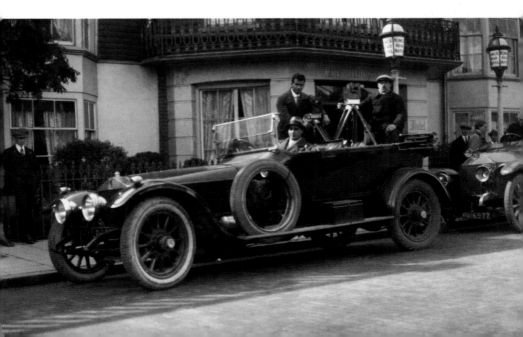

William Friese-Green was an early British film pioneer whose inventions contributed to the development of the film camera.

is where *The Glorious Adventure* (1922), Britain's first full-length colour film, was made, using the Prizma two-colour system.

The volatile highs and lows of the early British film industry are exemplified by the life and career of George Berthold 'Bertie' Samuelson. His first step into the industry was as a film distributor. At that time (the early 1900s) cinema owners would buy a programme of films from a distributor – maybe two features, a 'B' feature, and one or two shorts or cartoons. The cinema would then show the programme they had purchased till everyone in their community had seen it and the film was falling apart – at which point they would need to purchase another.

Samuelson struck upon the idea of renting programmes instead of selling them, thus enabling cinemas to show a new programme every week. His fortunes rose fast and he found that, with business booming, the one problem was lack of films to buy. So he decided the next step was to make his own. He initially shot on location and rented studio space at Ealing. In 1913 he purchased Worton Hall in Isleworth and converted it into a film studio. He named his new company the Samuelson Film Manufacturing Company.

Isleworth was really the first of the 'stately home' studios. Bray, Pinewood, Shepperton and Denham would all copy this model, being built on the estates of stately homes. Samuelson filmed scenes inside Worton Hall (just as Hammer would at Bray) and also built a glasshouse studio in the grounds. Known for his patriotic beliefs and championing of truly British subjects, Samuelson made several notable films, starting with the hugely successful *Sixty Years a Queen*, about Queen Victoria. Not all of his films survive and one of the lost films is *A Study in Scarlet*, the first ever Sherlock Holmes film.

Like other early film-makers, by the early 1920s G.B. Samuelson found himself having to compete in a busy market, which (especially in the days of silent film) included many foreign films. Having started with such flair as a young man, all too soon his 'palmy days' (as he would later refer to them) were over and he was bankrupt. He was to go bankrupt three times altogether, forcing him to sell his studios in 1928 and move to the south coast with his young family and no job.

By the time his son, Sydney Samuelson, was fourteen the family was struggling to survive at all. Sydney left school and got himself a job in the loca cinema as a 'rewind boy', working in the projection box. Having learnt his

trade and entered the industry as a projectionist, he then trained as a cameraman; while Bertie may not have known it, the Samuelsons would ultimately become one of the most important families in the industry, with Sydney becoming the first British Film Commissioner, and grandsons Marc and Peter becoming film producers.

British film-makers such as Bertie Samuelson faced two big problems between 1914 and 1929: the First World War, and the coming of sound. The First World War had a hugely destructive influence on film-making in Britain: experienced members of film crew were called up, many failing to return; and the film-watching audience was also hit – Britain as a whole had better things to do than spending money making films.

At the same time, civilian life in the United States was barely affected by the war raging in Europe. By the early 1920s the Americans were

developing new technology and techniques – so to British audiences British films started to look crude and unsophisticated when compared to the new Hollywood films. Britain's fragile film market was flooded with high-quality Hollywood films and war-torn Britain struggled to compete.

It was clear that the British film industry was struggling to survive and the passing of the 1927 Cinematograph Act was a turning point in British film-making. Not for the first time, the Government had decided that, in order to keep the industry alive, intervention was required (the first Government intervention in the British film industry had been marked by the Cinematograph Act of 1909). The Act dictated that a certain proportion (the exact percentage changed over the years) of all films rented and shown had to be British. It was hoped this would end the American domination of the British cinema box office. The Act had a galvanising effect on the studios, which suddenly found their stages filled by British and American production companies anxious to make as many 'British' films as quickly and cheaply as they could. Investment in the studios picked up to match the new demand and the films produced to meet the stipulations became known as 'quota quickies'.

Film historians, as well as contemporary commentators, have been split as to the benefit of this system. Long hours (some studios operated day and night), ridiculously tight schedules and low budgets led to vast numbers of low-quality films being made in Britain. Although there are exceptions to the rule, most 'quota quickies' are very much of a B-movie standard. However, the system kept studios open, encouraged the founding of new

A Study in Scarlet (1914) was produced by G. B. Samuelson and directed by George Pearson. It marks the first time Sherlock Holmes appeared on film, and starred James Braginton, an unknown accountant chosen for his resemblance to the published illustrations of Holmes.

9

studios, and created a hugely valuable training ground for actors and crew alike. There was little time for artistry or originality, but studios were able to offer continuous employment and crews became more experienced.

However, British film-makers were faced by yet another problem — the coming of sound. The wholesale arrival of sound in British film production took place over the year 1929–30. The Cinematograph Act had led to a demand for studio expansion, but the need to convert studios to sound was beyond the financial capabilities of many small studio owners. The huge investment needed to update studios and their equipment (as well as re-train crew) meant that many smaller studios disappeared at this time, but the survivors were able to benefit from the Act and move forward.

Freddie Young, cameraman, shoots a scene in a boxed-in camera for an early 'talkie'. The camera is boxed in to prevent the noise of its operation from ruining the sound recording.

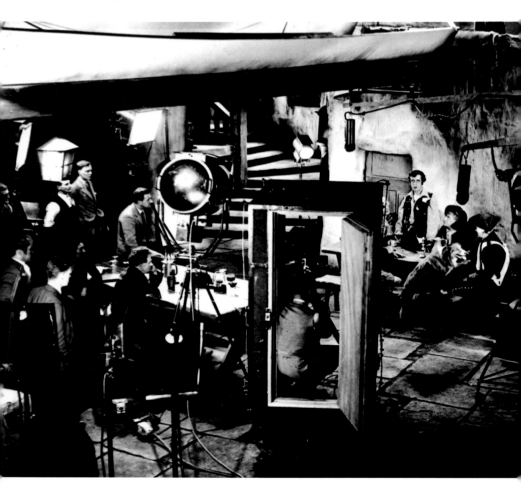

Several films claim to be the first British sound feature, but Alfred Hitchcock's *Blackmail* is usually accepted to be the holder of the title. Hitchcock was from the earliest days of his career keen to use new and emerging technology and filming techniques. He anticipated the imminent sound revolution and decided to make *Blackmail* in two versions – silent and sound. The sound version had additional scenes with recorded sound dialogue. The sequences requiring sound were shot in a small temporary sound stage built at Elstree.

New production companies were formed in the wake of the sound revolution, the most notable being Associated Talking Pictures under Basil Dean, who constructed a sound studio in 1931 with the assistance of RKO (one of the 'big five' studios in Hollywood at that time). It was built on the Ealing site where Will Barker had previously built his glasshouse studio. This became the first British studio purpose-built for sound production.

The coming of sound changed all aspects of film production. Within the studios, stages had to be soundproofed so that noise from other productions and the outside world would not ruin the sound recording. Location shooting suddenly became very difficult because sound-recording equipment was bulky and locations were noisy – so scenes that would once have been shot outside moved indoors.

Many of the early studios had inner-city locations where sound had never previously been an issue. Now film-makers found that their studios were difficult to soundproof. Of the many studios that had sprung up around Elstree and Borehamwood, Whitehall Studio was particularly affected. It had been built in 1928 right next to the railway lines and was soon nicknamed 'White Elephant' by those in the industry. At the Clapham Road Studio heavy fabric screens were erected in an attempt to improve the soundproofing but regular freight trains went through Clapham and the studio had to close.

The coming of sound also had an effect on other, less obvious aspects of filming. Towards the end of the silent era camerawork had developed and become more mobile, but the conversion to sound temporarily forced the camera back to a more static position. This was because noisy cameras had to be enclosed and baffled so their sound would not ruin the sound recording. Cameramen sat in enclosed booths built around the camera. Their visibility was impaired and they hated sitting in a stifling little cabin. This obviously needed to change, so it was not long before other solutions were found. 'Blimps' (padded covers) were introduced in 1931 and the camera and operator were liberated from the soundproof booth. By 1932 cameras were once again moving freely.

The need to record sound also led to a revolution in lighting technology. Arc lamps had previously been the chosen style of artificial lighting, but they proved very noisy for use on sync-sound productions and were quickly

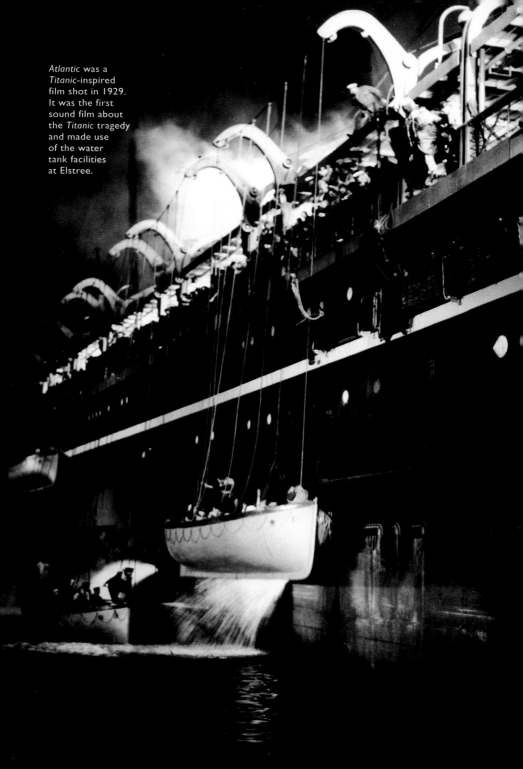

Atlantic was a *Titanic*-inspired film shot in 1929. It was the first sound film about the *Titanic* tragedy and made use of the water tank facilities at Elstree.

replaced by silent tungsten incandescent units. Tungsten lights give off a warm light, whereas arc lights create a cold white light, so the change in lights also necessitated a change in the film stock used.

The sound revolution – affecting as it did every other aspect of film production – had taken just a few years to change the British film industry for ever. In 1929 a temporary little shed was used for *Blackmail*'s sound scenes; by 1930 the British International Pictures (BIP) studio had constructed eight sound stages at Elstree. Elsewhere studios either invested heavily to update their facilities, or they were simply too small to keep up and they went bust, never to be seen again.

The Ghoul (1933) is a Gainsborough film starring Boris Karloff, produced by Michael Balcon. The crane used to suspend the microphone above the actors is easy to identify.

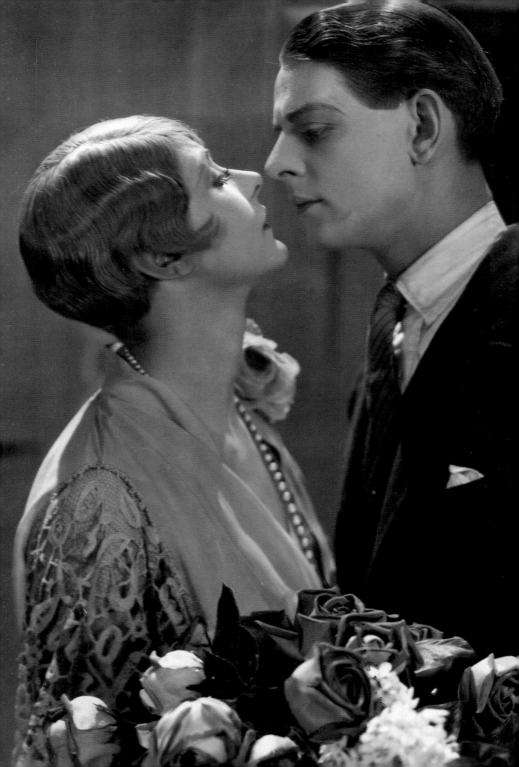

GAINSBOROUGH: FROM HITCHCOCK TO MELODRAMAS

T HE NAME GAINSBOROUGH may mean little to modern film fans, but this London-based studio was pivotal in the history of British film-making. Alfred Hitchcock spent his early career learning how to make films there, and throughout the 1940s the studio became famous for the 'Gainsborough Melodramas', which established the careers of many British film stars, including James Mason and Margaret Lockwood.

Michael Balcon founded Gainsborough Pictures in 1924, and in 1927 it became associated with the Gaumont-British Picture Corporation. That company had been set up by the Ostrer brothers in 1922 when Isidore Ostrer, with his brothers, Mark and Maurice Ostrer, acquired Leon Gaumont's holding in the French Gaumont Company.

When the Cinematograph Act of 1927 was passed, the Ostrer brothers sprang into action. Gaumont-British was revamped to become a vertically organised company – this is when the production, distribution and exhibition of a film are all contained within the control of the same company. The Ostrers now controlled two production companies (Gainsborough and Gaumont-British), two distribution agencies, and a cinema circuit that would eventually include 350 cinemas. The brothers themselves were each involved in different aspects of the family business (with Maurice taking an active role in film production as Gainsborough's head of production at the studio between 1943 and 1946).

Gainsborough/Gaumont-British had two separate studios at their disposal: one at Lime Grove (in Shepherd's Bush), the other in Islington. The first film studio at Shepherd's Bush had been built and then expanded by the Bromhead brothers, who had started a British branch of the (French) Gaumont Company in 1898. The large glass-covered studio at Lime Grove was opened in 1915. The Islington site had been built by an American company, Famous Players-Lasky. Keen to develop their interests in British production, they bought a railway power station in 1919 and converted it into a two-stage studio.

When Gainsborough joined forces with Gaumont-British in 1927, the two companies focused the production of higher-budget Gaumont-British

Opposite:
Easy Virtue
(starring Isabel Jeans and Robin Irvine, pictured) was shot by Hitchcock in 1928, just before the industry was turned upside-down by the conversion to sound.

pictures at the Lime Grove site, while Gainsborough concentrated on producing lower budget films at the Islington studios – although Gainsborough films were occasionally made at Lime Grove too.

Before Gainsborough was known for melodramas, it was known for Hitchcock. Hitchcock had been employed as a signwriter by Famous Players-Lasky at the Islington studio. When FPL sold the studio to Michael Balcon, Hitchcock stayed on and became part of the permanent studio staff at Gainsborough. Hitchcock wrote the scenario for the company's first film, *The Passionate Adventure*. He then worked as assistant on resident director Graham Cutts's early films at the studio. In 1926 Balcon gave him the break he needed and Hitchcock directed *The Lodger*.

Another famous British director who started out at the Gaumont-British/Gainsborough studios was David Lean. He began working at Gaumont in 1927, first as a tea boy and later as a clapper boy – learning the tricks of studio film-making and gaining camera crew experience that would prove very useful in his directing career.

The British film industry at this time employed many foreign film crew, including technicians from the United States, and also many from Europe. The German film industry (and the dramatically lit German Expressionist

This is how the old Gainsborough studio looks today; it has been converted to flats. Though it has been heavily refurbished, much of the right-hand side of the building is original.

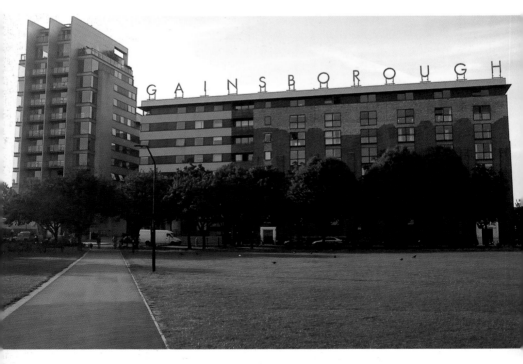

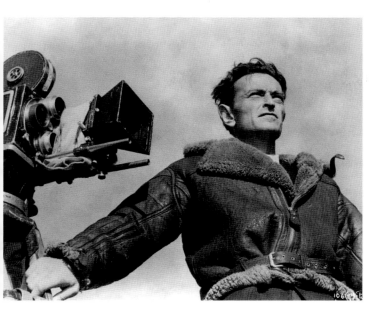

Director David Lean cuts a dashing figure during the filming of *Great Expectations* in 1946. He is wearing an RAF Irvine flight jacket.

Hitchcock filmed *The Secret Agent* at Gainsborough/Gaumont-British in 1936. His wife Alma co-wrote the screenplay. This shows the closing scene in which Richard Ashenden (played by John Gielgud) attacks Robert Marvin (Robert Young).

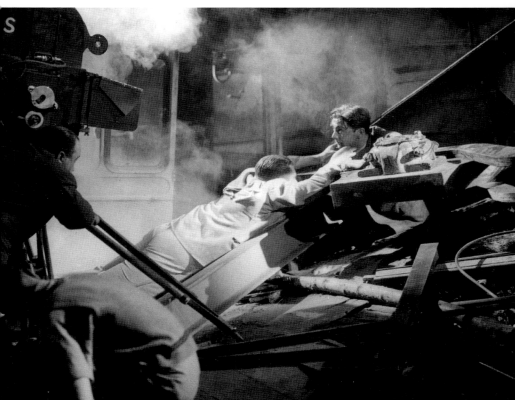

style of filming) was particularly influential in the 1920s and early 1930s, and at Gainsborough Hitchcock came into contact with many European cameramen and other crew.

Balcon encouraged his English crew to learn from the foreign technicians the studio employed. In this way British film-makers were influenced as much by European styles as by the dominant Hollywood films. Balcon made a two-picture deal with the German studio Emelka (in Munich) and Hitchcock directed *The Pleasure Garden* there in 1925 and *The Mountain Eagle* in 1926. These early influences, gained right at the start of his career at Gainsborough, made a significant contribution to Hitchcock's own signature style.

When sound films took over from silents, the Islington studio temporarily became home to both Gainsborough and Gaumont-British while Lime Grove was converted to sound stages for filming talkies. Having two separate studios gave the companies the flexibility to use one while the other was out of action.

Through the late 1920s and early 1930s the studios produced a wide variety of films but in 1936 Michael Balcon left to work in Hollywood for MGM-British. Shortly afterwards the Ostrers announced huge losses and, like so many other studios at this time, Gainsborough/Gaumont-British

Below:
The 39 Steps was an expensive film for its time (1935), much of the budget being used to pay its two stars, Robert Donat and Madeleine Carroll.

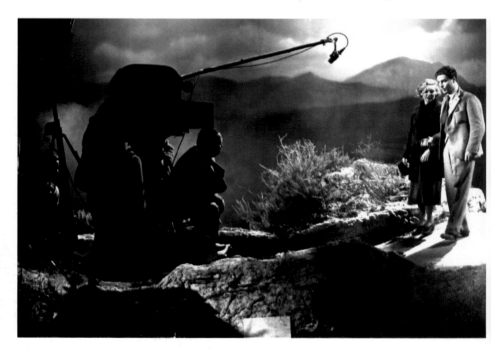

came to a joint agreement with J. Arthur Rank. Rank stipulated that productions based at Lime Grove should be moved to his new Pinewood studio, but that Maurice Ostrer could continue to make films under the Gainsborough brand at the Islington studio.

Leonard Harris, a camera operator, spent his early career working at the Gainsborough and Gaumont-British studios. As he remembers it, the studios were a good place to work, even in the hectic days of turning out quota quickies:

> Gainsborough and Gaumont-British (as it was) were good people to work for. The rates of pay as I gathered were generally above the average in the business but not perhaps as well as they were at Denham or somewhere like that ... They weren't so much worried about schedules in those days because they could work late to make up time and they didn't have to pay anybody any extra. The extras got paid more but there weren't so many of them you see. But nobody else got any money, they just had egg and bacon suppers.

The involvement of Rank and Maurice Ostrer's new position at Islington led to a change in the types of films produced, and the emergence of the 'Gainsborough Melodrama'. Within the studios Maurice Ostrer became

Gainsborough made *The Ghost Train* in 1931, mainly shot on location with the support of the Great Western Railway. Unusually, Gainsborough remade the same film ten years later, in 1941, this time as a vehicle for their popular star Arthur Askey. Walter Forde directed both versions.

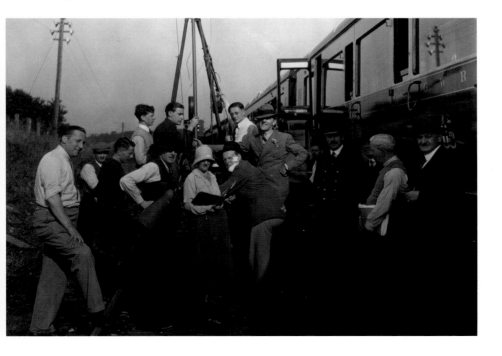

Maurice Ostrer was one of the Ostrer brothers who founded Gaumont-British, and he later became the production manager behind the Gainsborough Melodramas.

The Man in Grey (1943) is considered to be the first of what would become known as the 'Gainsborough Melodramas'. This publicity shot features James Mason and Margaret Lockwood.

more involved in his role as Head of Production and Ted Black assumed a greater role in the daily running of the studio. At this point in the history of the studio Rank was content to leave Ostrer, Black and the studio employees to go ahead making films with minimal intervention.

Ostrer and Black decided to pursue the home market and in the early 1940s began to dominate the popular British market with a series of historical melodramas starring the studio's contract stars. Unlike the Ealing Comedies, Gainsborough Melodramas have not continued to be popular with successive generations of film fans; their appeal was very much specific to the time in which they were made. Between 1943 and 1947, under the (some might say misguided) leadership of Maurice Ostrer, Gainsborough Melodramas were hugely popular, mainly with a female audience keen to see their favourite stars in another steamy situation.

Ostrer had guessed that, in a country still at war, what women wanted to see was escapist drama. The war had given more women the chance to live an independent life, and the liberated *femmes fatales* featured in the Gainsborough films appealed to these working women. Following the huge success of *The Man in Grey* (1943), three more melodramas were made in 1944: *Fanny by Gaslight*, *Madonna of the Seven Moons* and *Love Story*. Keen to keep up the momentum, Ostrer made three more in 1945: *A Place of One's Own*, *They Were Sisters* and *The Wicked Lady*.

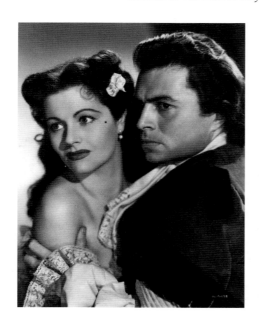

The films typically featured a cast of familiar stars, a dastardly male character and a *femme fatale* as well as two more virtuous male and female leads. They were never marketed as high art, and when, prior to its United States release, *The Wicked Lady* received criticism from the Hays Commission for the amount of heaving bosom on show this served only to boost publicity (although scenes had to be re-shot in order for it to be passed for United States distribution).

At the time these films were quite controversial – they portrayed attractive characters acting in a wholly immoral way, and the devious or manipulative women in particular contrasted greatly with the sweet

and modest female role models more usually seen in British films at that time. Lady Barbara Skelton in *The Wicked Lady* (played by Margaret Lockwood) steals her best friend's fiancé, gets married, gets bored with married life and gives it up for gambling, murder and highway robbery! Likewise, James Mason was not admired as a conventional romantic hero; instead, his on-screen persona was as a brooding bully. In *The Man in Grey* he whips Margaret Lockwood with a riding crop, whilst in *They Were Sisters* he drives his wife to drink and then suicide. This is what Gainsborough fans paid to see and wanted more of.

The Hollywood studio system, well established by the 1930s, relied on dependably bankable star actors being signed up to make films exclusively

Next page:
As this still from *The Wicked Lady* (1945) shows, Gainsborough Melodramas often Featured lavish sets and costume design. Here a cleverly painted backdrop and a crowd of extras in period costume give an important scene an epic feel. James Mason plays Captain Jackson, a highwayman sentenced to death by hanging, but who is rescued at the last minute

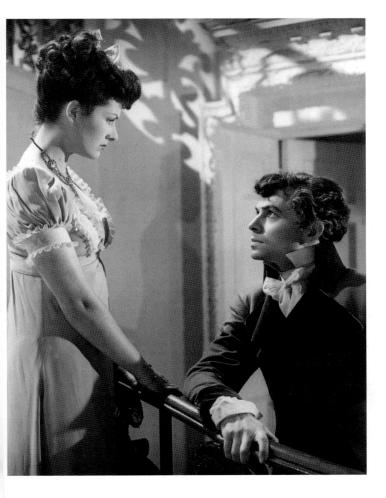

Left:
The Wicked Lady featured a female highway bandit (played by Margaret Lockwood, pictured here with her leading man, James Mason) and attracted huge cinema audiences.

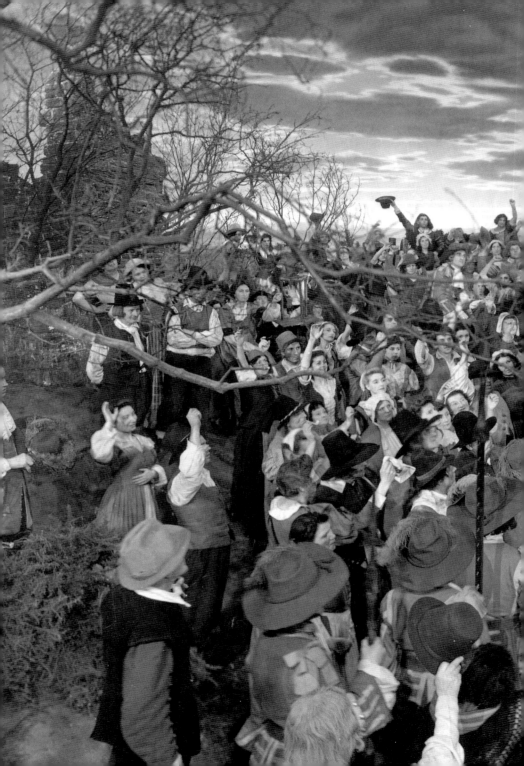

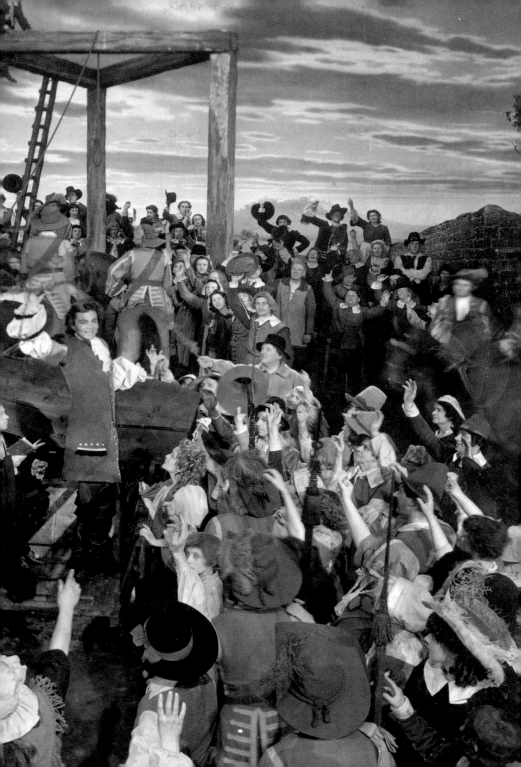

Fanny by Gaslight was one of the top British box- office draws in 1944 but in the United States fell foul of the Hays Purity Code. Featuring an illegitimate heroine, a morally corrupt but attractive villain, and scenes in a brothel, the film violated almost every point set out by the code. Eventually seventeen minutes of the film were cut for the American market

for one studio. The studios in Britain were influenced both by European and Hollywood film-making, but the 'star system', as it was known, was never implemented as completely as it was in America. However, Gainsborough is a good example of a British studio that did have a cast of regular actors; indeed, to a contemporary audience one of the most recognisable aspects of a Gainsborough film was the familiar cast.

The key Gainsborough cast typically (although not always) included James Mason, Patricia Roc, Stewart Granger and Margaret Lockwood. While working at Gainsborough, James Mason mirrored his dastardly screen persona somewhat and had an affair with the already married daughter of Isidore Ostrer, Pamela Kellino. She subsequently became his first wife. Of those four actors James Mason remains the best-known, mainly because he pursued a very successful Hollywood career after he left Gainsborough. Stewart Granger also had some success in Hollywood, but Patricia Roc made only one film there, while Margaret Lockwood returned to a career on the stage after her Gainsborough career ended, and later worked in television.

Opposite:
Madonna of the Seven Moons (1944) starred three of Gainsborough's best-known stars: Stewart Granger, Patricia Roc and Phyllis Calvert.

It is worth noting that, despite their notoriety, not even half the Gainsborough films produced in the 1940s were melodramas and the studio produced many films of other types before, during and after this period. The popularity of the melodramas was short-lived but is remembered because the 'Gainsborough Melodrama', like a Hammer Horror or an Ealing Comedy, is a clearly defined and recognisable product in the long history of British film-making.

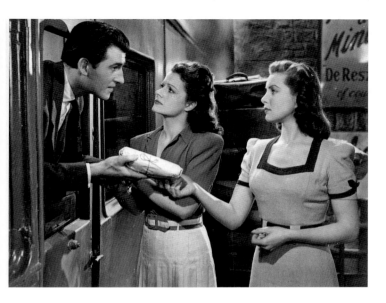

Left: *Love Story* (1944) is a romantic melodrama which used a contemporary setting rather than the overblown period setting often favoured by Gainsborough. The film starred Gainsborough regulars Stewart Grainger (left), and Patricia Roc (right), with Phyllis Calvert (middle), John Stuart and Reginald Tate.

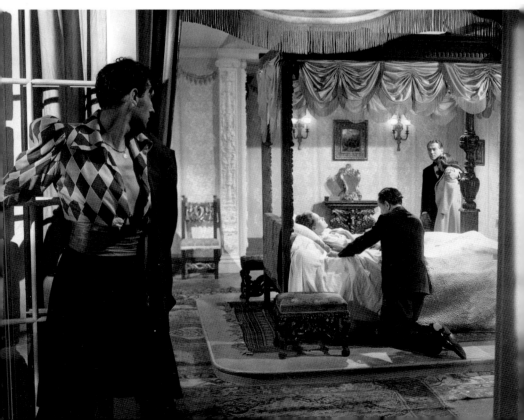

However, Maurice Ostrer did Gainsborough no favours by concentrating so closely on a single type of film. By the end of the war, Gainsborough's melodramas were already falling out of fashion. Two more films were made in 1946 but *Jassy* (1947) was the last 'official' Gainsborough Melodrama. Even the addition of Technicolor was not enough to revive the brand.

At this point the Rank organisation became more involved in what was being produced at Gainsborough. Ostrer left and was replaced by Sydney Box. Box was a successful independent producer who had produced his Oscar-winning film *The Seventh Veil* in the most difficult circumstances, filming at Riverside Studios during 1944–5 when the London-based studios were damaged by shrapnel, and bombing of the surrounding area constantly disrupted sound recording. His success as an independent film-maker led the Rank organisation to ask him to run the Lime Grove and Islington studios.

With his family in tow, Sydney Box arrived at Gainsborough to find that many of the studio crew resented his arrival following the resignation of their previous boss, Maurice Ostrer. Never ashamed to indulge in nepotism,

By the time *Jassy* was made in 1947 the melodramas were losing their popularity. It was hoped that shooting in Technicolor would boost ticket sales. This production shot shows the crew on location.

Box put his wife Muriel in charge of scripts, and sent his sister Betty over to run the studios at the Lime Grove site.

Although Box had a proven track record when it came to quality film-making, on his arrival at Gainsborough Rank pressured him into helping them fulfil their Cinematograph Act requirement. He undertook an ambitious production schedule to produce twelve films a year. Running the studios and stepping up production left Box little time to create original screenplays or develop films fully before they went into production. Box worked himself and his studio staff hard and within three years he fell seriously ill. It has been argued that mismanagement by Rank had led to a creative producer burning himself out and a previously popular studio making films so fast that it lost its popular audience. Rank cut his losses and Gainsborough studios were closed in 1950.

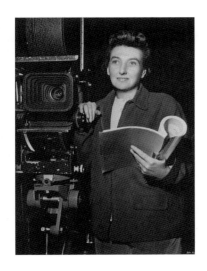

Muriel Box joined her husband Sydney when he was hired by Rank to run Gainsborough. She later became a director in her own right.

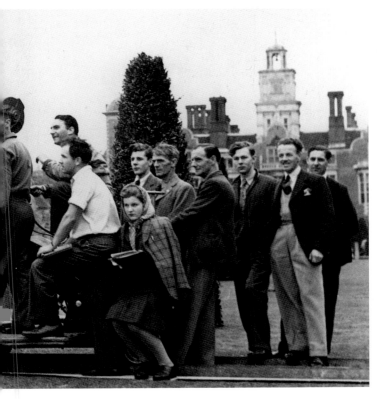

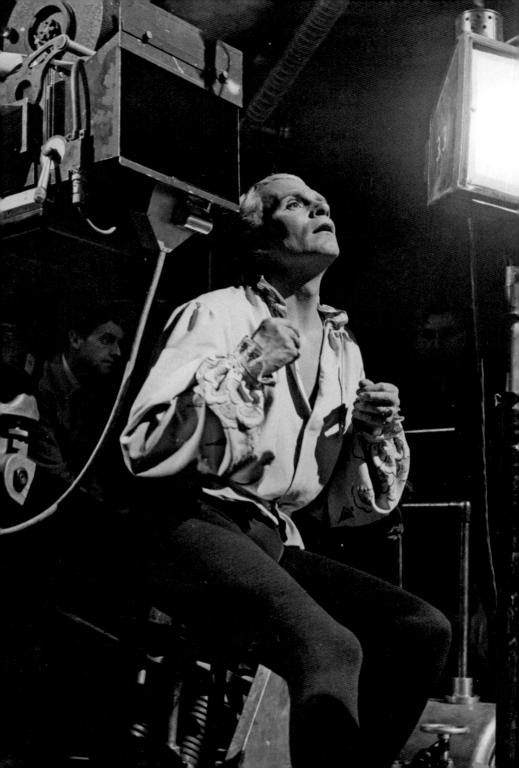

DENHAM: KORDA'S DREAM

Denham studio was founded by Alexander Korda in 1936. Korda was born Sándor László Kellner in Hungary in 1893 and established himself as one of Hungary's top film directors before he chose to flee abroad in 1919 to escape the rising political unrest and anti-Semitism in his home country. Korda, like many other pioneers in the British film industry (such as Michael Balcon, the Ostrers, the Samuelsons and Victor Saville), was Jewish. He continued his film career, gaining invaluable experience working in the film industry in Austria, Germany and then the United States, before arriving in England in 1931.

Korda was known for his charm and his powers of persuasion as a businessman. He managed to secure a unique directing contract with the American company Paramount. Like other American film companies, Paramount was being forced by the Cinematograph Act to increase the production of British-made films. While the act was designed to boost British production companies, replacing American products with British ones, in practice the Americans got around the compulsory quota by funding their own 'British' films (although at least British studios and crew still benefited from this). Paramount's agreement with Korda would allow them to fulfil the quota and also to import a larger number of their own popular films.

Korda has often been criticised for his nepotistic approach to film-making, employing his two brothers in key positions (Zoltan as director and Vincent as art director). However, when you look at the British film industry as a whole it becomes clear that this is an unfair criticism: his brothers were talented men in their own right, both being nominated for Oscars for their work. Nepotism was endemic in the British film industry, and always had been, from early film-maker James Williamson, whose Hove-based studio turned out films starring his own family members, through to the later Ostrers (at Gaumont) and Sydney Box (at Gainsborough).

Having founded his own production company, London Film Productions, Korda struck lucky with his first few British films, and had particular box-office success with *The Private Life of Henry VIII* and *The Scarlet Pimpernel*.

Opposite:
Laurence Olivier directed himself in three Shakespeare adaptations at Denham, playing the lead roles in *Hamlet*, *Henry V* and *Richard III*. Here he directs a scene from *Hamlet* (1948).

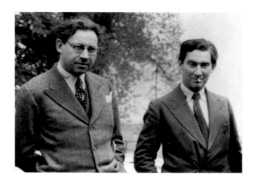

Hungarian director and entrepreneur Alexander Korda (left) with his art director brother, Vincent (right). The Korda brothers made a big impact on the British film industry.

The Private Life of Henry VIII was the first British film to enjoy great success in the American market and was nominated for an Academy Award for Best Picture.

The huge financial successes of these films led Korda to be offered a seat on the board at United Artists and a large number of shares. Korda had succeeded in gaining a distribution agreement in the United States for all his future London Films releases – a first for any British film company. Never lacking in ambition or imagination, Korda's next decision was to build his own studio. By chance the Prudential Insurance Company was looking for British projects to support at that time and Korda's hugely profitable films convinced them that the British film industry was the ideal area in which to invest. The Prudential gave Korda the funding he needed to build a brand-new studio complex.

Korda identified a perfect site on which to build Britain's newest film studios, a 193-acre estate (including a stately home and a stretch of river) near the village of Denham. Building took just under a year and the studio opened in May 1936. John Aldred, who became an employee in the sound department at Denham, wrote:

There are many stories about the building of Denham: how lorries full of timber and other materials would arrive at an entrance, drive right around the plot and exit without being unloaded; how the River Colne was diverted to make a pond in front of Alex's office; how his great friend Winston Churchill stocked it with some of his own swans; how Alex's office was full of expensive antiques; how a Hungarian chef was imported to run the studio restaurant. The list is endless.

The Private Life of Henry VIII (made in 1933 and starring Charles Laughton) was a huge financial success and is directly responsible for the investment Alexander Korda subsequently secured to build Denham Studio.

Korda was spending money like water. This carried through to the creative talent he was trying to lure from the other studios. Brian Desmond Hurst, a director, had been offered a film-directing contract

by BIP that paid him £40 a week plus £500 for each film he made. Then in 1937 he was head-hunted by Alexander Korda at London Films, looking for talent to sign up for the permanent staff at his new studio at Denham. Korda offered him a three-picture deal with £3,500 for the first film, £5,000 for the second, and the almost ridiculous figure of £10,000 for the third. BIP was unable to agree to even half that amount, so Hurst moved.

On paper, and to Korda and his investors, Denham looked like the ideal modern studio. It featured seven sound stages, the latest sound and lighting technology, film craft workshops, and film-processing laboratories. The layout of the buildings was designed by a Hollywood architect, and Korda intended this to be the ultimate modern studio. He had even negotiated special arrangements with the Great Western Railway to provide fast trains between London and Denham.

Denham was of course competing against the other established studios, particularly the still quite new Pinewood. Gordon McCallum, a member of the sound crew at Pinewood in the 1930s, recalls:

> I think there's always been rivalry to some extent – friendly rivalry. Between Denham and Pinewood there was a little difference and I don't know why … Korda made such a difference to Denham … he was talked about so much and his films were talked about so much and he had been so successful with the various things that he'd done – that I'm afraid we got the feeling at Pinewood that the lads at Denham were a little bit snooty.

Unfortunately, when it came to working there, Denham failed to deliver on its promise. The studio was just too large for existing industry requirements and the layout of the buildings over the huge site made various departments inconveniently far away from each other. The enormous site had huge running costs and in order just to break even the studio needed to book a busy schedule of in-house film production as well as plenty of paying independent customers. The payroll alone was approximately £20,000 per week.

London Films had already started to lose money during the building project and by 1938 Korda's chief investors realised that Korda himself needed to be removed from his position if Denham was ever to make a profit. Following pressure from his investors, Korda eventually stepped aside in 1939 and the Prudential took control of the studio, placing one of their own accountants in charge, and employing their own studio manager. Korda was allowed to continue with his own film productions but only as an ordinary tenant. Control of the studios ultimately went to his rival in business, the J. Arthur Rank organisation.

This must have been a terrible personal blow to Korda, but ultimately both Korda himself and Denham Studio recovered from this early stumble

Michael Powell and Emeric Pressburger met through Alexander Korda and went on to collaborate for many years through their company The Archers.

to achieve career success. The first Technicolor film to be made in Britain was made at Denham (*Wings of The Morning*, 1936). By the end of the 1930s, J. Arthur Rank owned a number of different studios and Denham's stages were rented out to many different production companies through the late 1930s and early 1940s.

Like many other British studios at this time, Denham became home to a motley collection of foreign crew, many fleeing from the increasingly volatile situation in Germany and the rest of Europe. Denham had such a large number of Europeans working there during Korda's time that the main studio thoroughfare was jokingly referred to by some as 'the Polish Corridor'.

It was in this environment that one of Britain's most important cinematic partnerships was formed. Director Michael Powell (who was British) met Hungarian-born writer Emeric Pressburger at Korda's London Films in 1938. Powell had learnt his trade making 'quota quickies' (and had worked with Hitchcock on *Blackmail*) while Pressburger had worked at the UFA (Universum Film AG) studios in Germany before coming to England in 1937. Korda brought Powell and Pressburger together in 1938 to make a film of Joseph Storer Clouston's novel *The Spy in Black*. It was very successful and when Korda left the studio

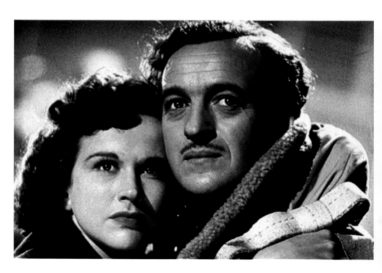

A Matter of Life and Death (1946), starred David Niven and Kim Hunter, and helped to establish Powell and Pressburger as one of Britain's most talented film-making teams.

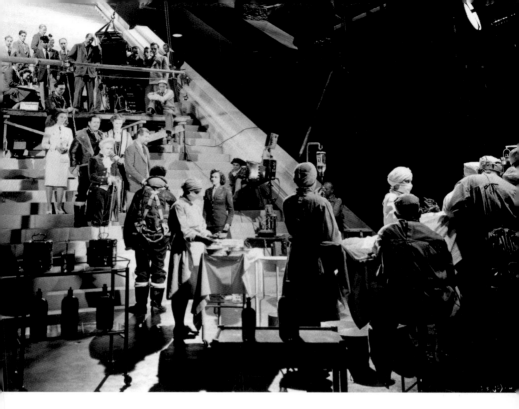

just before the war Powell and Pressburger carried on making films together at Denham. They founded their own production company, The Archers, in 1943. Along with the hugely influential cameraman Jack Cardiff, the team made *The Life and Death of Colonel Blimp*, *A Matter of Life and Death* (both at Denham), *Black Narcissus* and *The Red Shoes* (both at Pinewood).

At the outbreak of war, Denham was requisitioned by the Government, but, unlike at some other requisitioned studios which became factories or warehouses, feature films continued to be made. According to John Aldred, who was working in the studio at the time:

> On 3rd September 1939 (which was a Sunday) a large unit was at work on the Basra set [for *The Thief of Baghdad*]. When Alex heard that war had been declared, he stopped all shooting and put the extras to work filling sandbags to protect the studio entrance against expected air assault – which did not materialise.

Rank's flagship studio, Pinewood, was out of action, so the company moved film production to Denham. It was cheaper for Rank to concentrate production at Denham, and the studio was suddenly busy making low-budget films.

A Matter of Life and Death is innovative for its use of both colour and black-and-white segments in the narrative. Here a dream sequence is being filmed, hence the strange assortment of costumes. Jack Cardiff was the director of photography, and was particularly known for his skill in shooting Technicolor.

This wonderful production shot of the *Great Expectations* camera crew shows that, in 1946, working as film crew was a jacket-and-tie job.

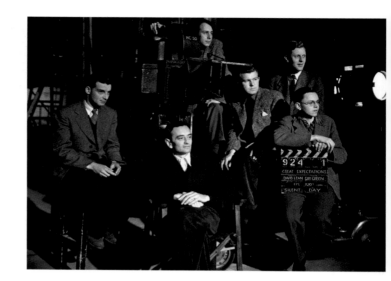

The sequences set in a lifeboat led to weeks of filming in a water tank for the cast and crew of *In Which We Serve* (1942).

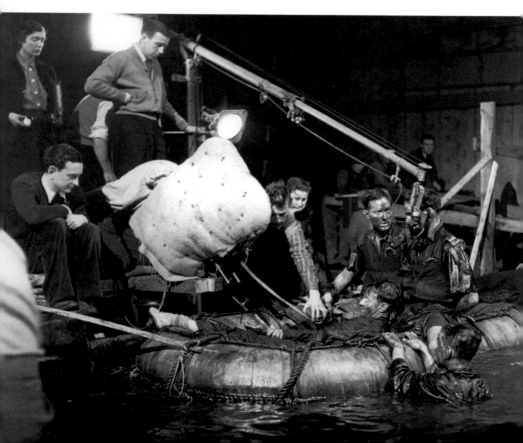

It was also full of film companies that had been temporarily evicted from other studios and needed stages to rent. Denham under Rank was a far more ordered place than it had been under Korda, but, as a renting director, Korda was still a regular presence at the studio.

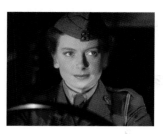

The Life and Death of Colonel Blimp was filmed in 1943 at Denham – one of the very few studios to continue making feature films during the Second World War. Here Deborah Kerr appears in the film as a military (F.A.N.Y.) driver.

For Denham the war years were a productive time. The films made there included the iconic Second World War films *In Which We Serve* and one of the studio's most successful releases, *Brief Encounter*. Denham employees and film crew must have shared in David Lean's delight when the film picked up Academy Award nominations for Best Actress, Best Writing and Best Director.

Korda himself had an interesting war. He moved to the United States in 1940 but travelled back several times during the war. When he was knighted by King George VI in 1942 for his services to the war effort (the first person in the film industry to be recognised in this way) there was speculation that his mysterious work during the war had been carried out for Churchill and the Secret Service. In 1943 Korda became the production chief at MGM-London – a position that ended after a year when he had incurred large losses. He also spent time working at Shepperton Studio and before his death in 1956 he was involved in many other successful films and somewhat less successful business ventures.

Alexander Korda was well known for his charm and good connections. Here he takes a stroll with Cary Grant.

Despite having been rescued by Rank, by the end of the 1940s (less than a decade after opening) Denham was in trouble again. The Rank empire was crippled by huge debts and most production at Denham ceased. A small amount of the studio was leased to Twentieth Century Fox and the final closure did not happen until 1951, when Disney's *Robin Hood* became the last film made there. Denham was demolished by developers in the 1970s and there is no visible sign of Korda's studios: a sad end to an ambitious studio.

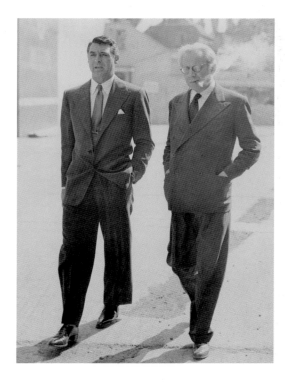

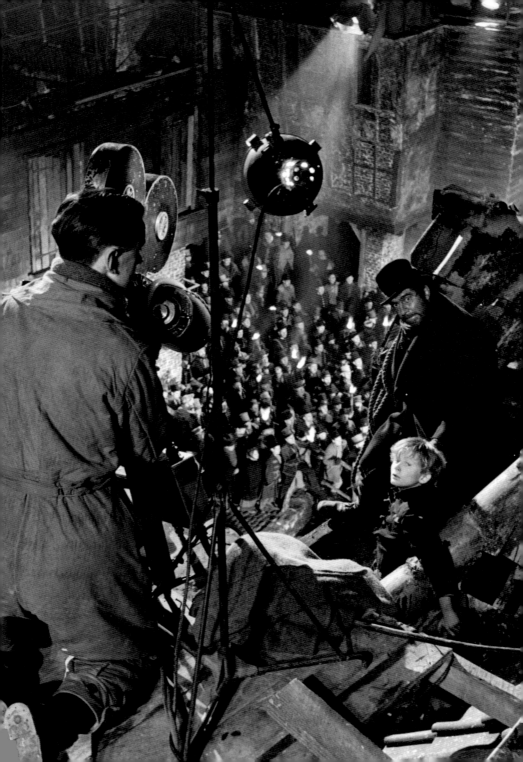

PINEWOOD

PINEWOOD has become Britain's best-known studio — and part of this reputation is linked to its longevity. While old studios at Elstree, Ealing and Shepperton have survived but have been greatly changed or reduced, Pinewood survives intact, its 1930s buildings still in use, and many more recent ones have been added.

The name of J. Arthur Rank comes up in nearly every chapter of this book, but it is Pinewood that marked his first step into studio ownership. Rank, more than any man before or since, must be rated as the most influential person in the British film industry. Unlike Korda and Balcon (who both had many years of film-making experience before becoming involved in studio management), his entry to the film world was almost by chance. Heir to a successful flour-milling business, Rank spent the earlier part of his career involved in the family company and as a philanthropist, supporting the Methodist Church.

When he was trying to make and distribute religious films in the early 1930s, it became clear to Rank that the British market was dominated, both at production and distribution level, by American companies. With advice from a young film producer called John Corfield, Rank, with Lady Yule (at the time known as one of the richest women in Britain), set up the British National Films Company. They made one film before deciding to get more deeply involved in the industry, and in 1935 Rank became, with Yule and Corfield, a joint owner of Pinewood Studios. Rank was forty-seven, and may not have realised that he was beginning the most fruitful period of his career, in an industry that was entirely alien to him.

The site of Pinewood, near Iver Heath in Buckinghamshire, was chosen for several reasons. Like Shepperton, Denham and Bray, it included a swathe of landscaped land, useful for back-lot filming, and was located near enough to London for easy access, but far enough to escape the London fogs that were still notorious at that time. The site also included Heatherden Hall, which at one time had been used as a retreat and private meeting place for politicians and diplomats. Charles Boot bought the estate in order to turn it

Opposite:
This remarkable shot shows the production of David Lean's *Oliver Twist* (1948), with camera crew and actors perched precariously above a set packed with extras. The film is about to reach its finale, with Bill Sykes (played by Robert Newton) dragging Oliver (John Howard Davies) onto a high rooftop. The camera operator may well be Ossie Morris.

into a country club, but was quickly convinced by Rank to build a studio there instead. The name Pinewood was chosen both in reference to the wooded back lot and also in homage to Hollywood, which the studio owners hoped their British studio might eventually emulate.

In 1937 Rank began to realise that in order to work more efficiently he needed to control the film-making process from production (in a studio) right through to distribution and display (in cinemas around the country). By 1942 the Rank Organisation had become what is known as a vertically integrated film company. This means that from the making of the film right through to the cinema screening of it each step was controlled by a single organisation. Rank owned studios at Elstree, Denham, Lime Grove, Islington and Pinewood, as well as distribution companies and a network of cinemas. While he was not a creative force in his own right, Rank's business sense and financial backing enabled his studios to flourish, his film directors to have the funding they required, and the finished films to benefit from good distribution.

This historical aerial view of Pinewood Studio shows the impressive Heatherden Hall in the foreground, right.

The studio was officially opened on 30 September 1936 and entered directly into a busy period of production, but it barely had time to get established before production was cut short by the start of the Second World War. Gordon McCallum, a sound engineer working there at the time,

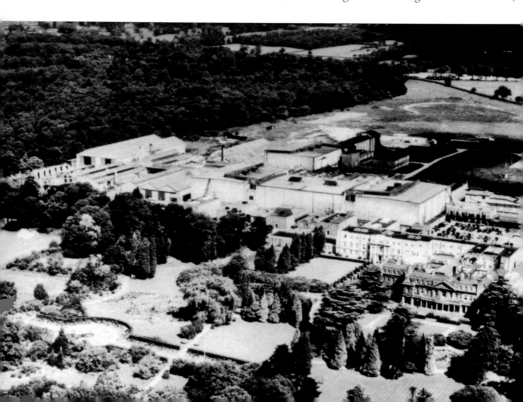

remembers 'The film industry was in some difficulties and work was concentrated at Denham, so we were all laid off at Pinewood and it was a scramble to find a job somewhere else.'

At the start of the war film production came almost to a standstill as the country became preoccupied with more important concerns. However, the Government quickly realised that film could become an important tool to keep up morale at home and also to disseminate propaganda abroad.

Pinewood was requisitioned by the Government and became, from 1942, the home to the Army Film and Photographic Unit (AFPU), the RAF Film Unit and the Crown Film Unit (as well as the Royal Mint and Lloyds of London). The various film-making units were set up to make propaganda films in Britain, and to train combat photographers and film-makers to record accurately what was happening on the front line overseas. The men and women who passed through Pinewood's gates to be trained provided a core of experienced crew and were a huge boost to the post-war British film industry. Richard Best, a film editor with the Army Film and Photographic Unit, recalls: 'It should always be remembered that Pinewood in the war years was a hive of creative energy and a most exciting place to be.'

The AFPU had been set up in 1942 to carry out two equally important roles: to document, in film and stills, the experiences of front-line troops

In this recent aerial view of Pinewood, it is easy to identify the expansion of the site. The Paddock Tank with its blue-screen backdrop is also clearly visible.

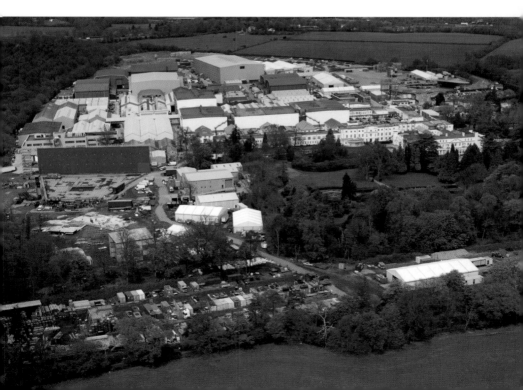

This photograph was taken to celebrate the end of the war and the return of Pinewood into film production. J. Arthur Rank is surrounded by a group of his leading actresses. Shown left to right are: Jean Simmons, Valerie Hobson, Rosamund John, J. Arthur Rank, Patricia Roc, Judy Campbell, Jean Kent and Sally Grey.

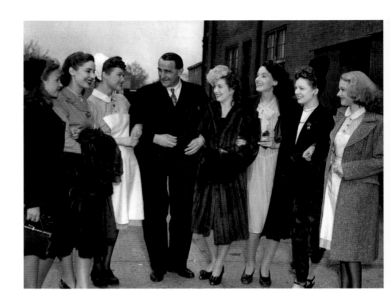

in every arena of war; and to produce propaganda to boost morale at home. The Germans and French had been quick off the mark and from the start of the war began producing large amounts of high-quality film footage.

Professional photographers and cameramen of military age had already been called up and were serving in other regiments. When the AFPU initially started recruiting, these men were located. Pinewood studios had now been painted in camouflage and masked from enemy aircraft with netting. When the military film units were given Pinewood to use as a base and teaching facility, it was not unusual for some crew members to find themselves back at the studio doing the jobs they had given up just a few weeks previously, before war had been declared.

Larry Thompson, a member of the sound crew, recalls:

After initial military training, my request to join the RAF Film Unit was successful and I was posted to Pinewood. It was strange being back there in uniform, rejoining the friends I had previously worked with in civvy street. I was sent on a course of instruction on the use of cameras in combat and was issued with a 35mm still camera and a 16mm magazine loading Cine Kodak camera.

However, it was soon felt that recruitment should be widened to include soldiers with no previous qualifications. In order to become combat

cameramen (or other front-line crew), the recruits needed to have the ability to learn the skills of the film trade, combined with previous military expertise, initiative and bravery. Soldiers (and RAF personnel) with no previous experience were trained from scratch at Pinewood. The AFPU documentary *Desert Victory* was awarded the Oscar for the best documentary war film in 1943.

Paul Clark, who served in the AFPU, recalls:

> While discipline was maintained the whole atmosphere was relaxed. Silk
> pyjamas, dressing gowns, cravats, suede shoes were not unknown in the
> former band room where the other ranks were billeted, while the NCOs
> occupied the dressing rooms, complete with mirrors and lights.

The film and photography training school set up at Pinewood was also used by other countries; for example, members of similar units from the Canadian, Norwegian and Polish forces also received training there.

Richard Attenborough had put his acting career on hold to join the RAF when he was eighteen. He had completed the first part of his pilot training when in 1943 he was asked to report to the RAF film unit at Pinewood. Attenborough had been hand-picked by Flight Lieutenant John Boulting, who was making a propaganda feature film, *Journey Together*. Boulting's identical twin, Roy, was involved in the AFPU, also based at Pinewood.

By April 1946 Pinewood was again a civilian studio and it began post-war production with three classic films by the top directors of the time. David Lean made *Oliver Twist* in 1948. In 1947 Powell and Pressberger abandoned Denham in favour of Pinewood and chose to make *The Red Shoes* and *Black Narcissus* there. However, in 1948 the Rank organisation took a different turn, and Powell and Pressburger would soon leave Pinewood in favour of Shepperton.

In 1948 John Davis became the managing director of the Rank organisation. Davis was an accountant by trade, and his interest was in keeping the company profitable – he had no real passion for the artistic side of film-making. Under Davis, Rank moved much of its production to Pinewood, where he encouraged

*The Red Shoes
(1948) was
another triumph
for Powell,
Pressburger and
their director
of photography,
Jack Cardiff. It has
become one of
their best-loved
films and made
a huge star
of ballerina
Moira Shearer.*

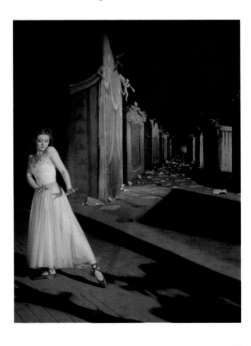

Although camera dollies existed in the 1940s, Steadicam certainly did not. On the set of *Oliver Twist* (1948) camera operator Ossie Morris (who later became an Oscar-winning cinematographer) sits in a pram to achieve the shot David Lean wants.

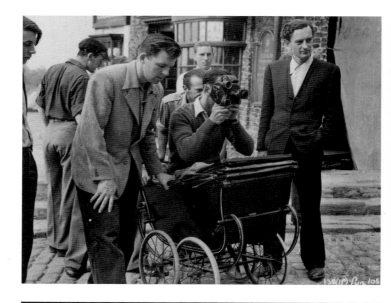

Right: *A Night to Remember* (1958) contains many scenes shot in a water tank. Here Kenneth More laughs in a break from arduous filming.

Opposite, top: Dirk Bogarde has fun in a break from filming on *Doctor in the House* (1954) – the first in a series of films that brought success to Pinewood.

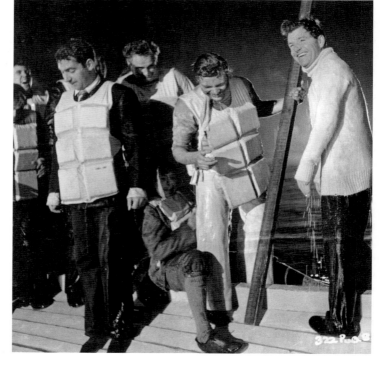

the production of unchallenging, 'family friendly' films at the expense of anything more intellectual. While he kept Pinewood in profit, he drove many of Britain's talented directors to Shepperton.

By 1949 the studio had fully recovered from the wartime lull and had started to achieve the busy production schedule that had been anticipated when it was built in 1935. Pinewood was not known for a particular genre of film: the slate of films produced over this busy period was diverse, with historical dramas, comedies, melodramas, war films and romances.

However, Pinewood *has* become known for three long-running series of films. The first of these began in 1954 with *Doctor in The House*. The film was directed by Ralph Thomas and produced by Betty Box, who had moved to Pinewood after the end of her brother's association with Gainsborough Studios. The film starred Rank contract star Dirk Bogarde (as well as Kenneth More, who won a BAFTA for Best Newcomer for his role). The film was the top British box-office hit of 1954 and was followed by six sequels.

Rank consciously looked to Hollywood for ideas on how to run his studio and, keen to emulate the Hollywood 'starlet' system, he established what would become known as the Rank Charm School, or Company of Youth (this had originally been the idea of Sydney Box during his time as studio manager at Gainsborough). Rank signed up contract stars, and the actors were then expected to take whatever roles they were offered, and to appear at any publicity events Rank organised for them. Many notable actors came through this system, including Christopher Lee, Joan Collins and Diana Dors.

In 1958 another well-known series began its life at Pinewood with *Carry on Sergeant*. Whatever can be said about their quality, the Carry On films were hugely popular, and their continuation from 1958 through to 1992 served to bolster film production at Rank's studio through several quiet patches when other studios struggled to survive. The director of the early Carry On films, Gerald Thomas, was the brother of Ralph Thomas, who directed the Doctor films.

Pinewood can claim to have been the most glamorous of the British studios. This was partly due to the elegant café (in the ballroom of Heatherden Hall), but it must also be because some of the world's biggest stars have shot at Pinewood. Marilyn Monroe made her only British film

Following pages: *Carry On Cleo* was produced in 1964, just a year after the epic *Cleopatra*, starring Elizabeth Taylor, had abandoned Pinewood to shoot elsewhere. The Carry On production was able to utilise many of the remaining sets, and in this shot it is easy to see how the opulent design and accurate period detail of the Taylor film contrasts with the usual – rather less period accurate – Carry On 'look'.

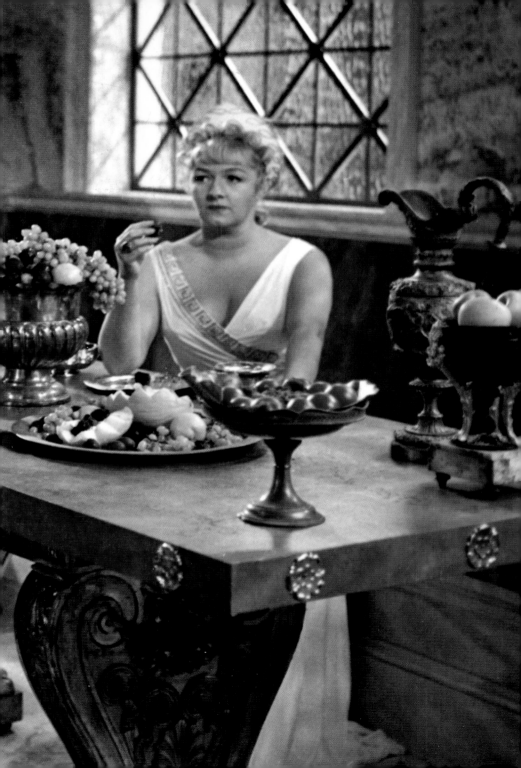

there in 1957 (*The Prince and the Showgirl*) and in 1963 Elizabeth Taylor and Richard Burton fell in love on the set of *Cleopatra*.

The series that has most closely been associated with Pinewood is the James Bond films, the (officially) first of which, *Dr No*, was released in 1962, starring Sean Connery as the first Bond. The film was produced by Harry Saltzman and Albert R. Broccoli, who went on to work on all the Bond films from then until 1975. It is unlikely that anyone working on the film could have anticipated that the series would continue with such uniform success. Lawrie Read was a new sound trainee at the studio, and he remembers vividly: 'At the age of seventeen years I was standing feet away from the gorgeous Ursula Andress "dressed" in her iconic white bikini. I looked down on her from the lighting gantry; I had gone to heaven at an early age.' Lawrie is still based at Pinewood and, after his company was involved in the post-production of *Skyfall*, can make the unusual boast that he has worked on the first and the most recent Bond films.

The Bond films have become so important to Pinewood that many parts of the studio have now been renamed to reflect this special relationship.

Carry On Doctor (1968) was just one of the Carry On series that kept Pinewood busy making films through several quiet periods for the industry. This shot features cast regulars Bernard Bresslaw, Kenneth Williams, Sid James and Frankie Howerd.

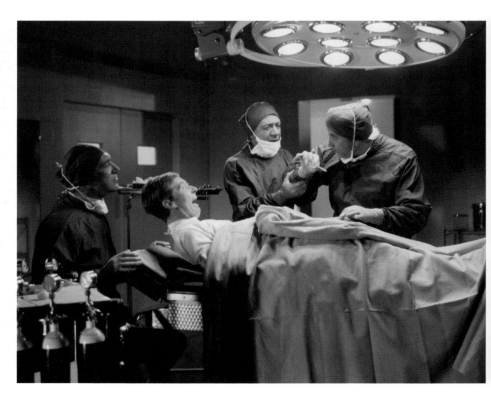

The Pinewood 'streets' include Goldfinger Avenue and 007 Drive.

By the 1960s the British film industry was going through a very difficult slump in production. The studios had to change in order to survive, and they decided to cut the huge overheads associated with a large, permanent crew. The 'four walls' system offered a way to cut costs and has since become the standard for all British studios. A production company rents the sound stage and any other space they need, then contracts separately for additional facilities and hires in a freelance crew.

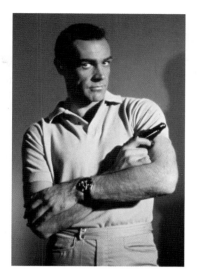

Sean Connery poses for a publicity shot as James Bond, for the first official film of the 007 series, *Dr No* (1962).

Pierce Brosnan as Bond is lined up for a shot on *Die Another Day*, which was made at Pinewood in 2002.

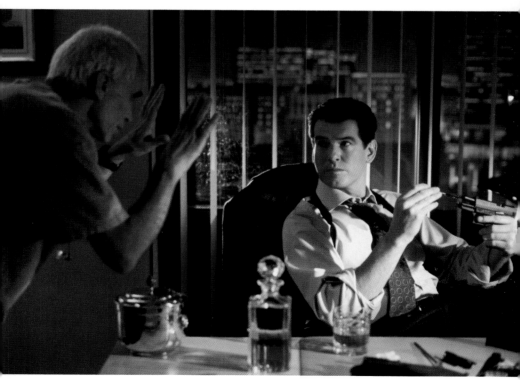

The loss of a permanent studio staff changed Pinewood for ever. The sense of community cannot be the same when independent film production companies come and go on a weekly basis, bringing their own catering vans instead of eating together as the crews on all the films used to.

While the way in which the studio is run has developed, other aspects of Pinewood have barely changed since it was founded. Films set at sea have always required the use of an outside water tank with an unbroken horizon. When Pinewood was built, a water tank was included. The tank was once rivalled by one at Elstree, but that was filled in and sold off for development. The enormous Pinewood tank has a capacity of roughly 800,000 gallons and remains one of the largest in Europe. These days the tank, known as the Paddock Tank, has a huge blue screen backdrop and has been used for films including *Skyfall*, *Pirates of the Caribbean: On Stranger Tides*, *Les Misérables*, *Sherlock Holmes: A Game of Shadows*, *The Boat that Rocked*, and *Atonement*.

Here film stars Barbara Bach and Roger Moore pose with producer Albert R. Broccoli in front of the remarkable set built in the 007 Stage for *The Spy Who Loved Me* (1977).

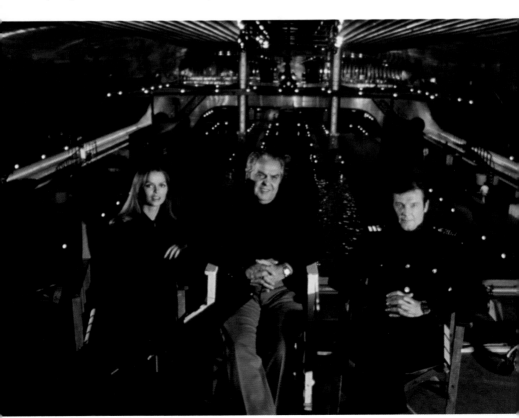

Pinewood is also well known for its huge 'Albert R. Broccoli 007 Stage', which was built in 1976 for the Bond movie *The Spy Who Loved Me*. In the decades since, it has been used by numerous famous productions to create colossal indoor sets, including the Louvre gallery for *The Da Vinci Code*, the chocolate river room for Tim Burton's *Charlie and the Chocolate Factory*, the theatre of vampires in *Interview with a Vampire* and a whole Greek village for *Mamma Mia*. The stage has burnt down twice, in 1984 and in 2006. Even modern film sets are vulnerable to accidental fires – the sheer quantity of lighting, electrical cables and wooden sets makes it an ever present danger.

The Rank group was to retain ownership of Pinewood long after J. Arthur Rank himself died in 1972. It was eventually acquired by a team led by Ivan Dunleavy and Michael Grade. Shepperton and Pinewood ceased to be rivals when in 2001 it was announced that the two famous studios had finally completed a merger, becoming one of the largest and most impressively equipped film-making facilities in the world.

This is Pinewood's famous Albert R. Broccoli 007 Stage – still one of the largest silent stages in the world. This is the same stage seen opposite, but rebuilt after two fires.

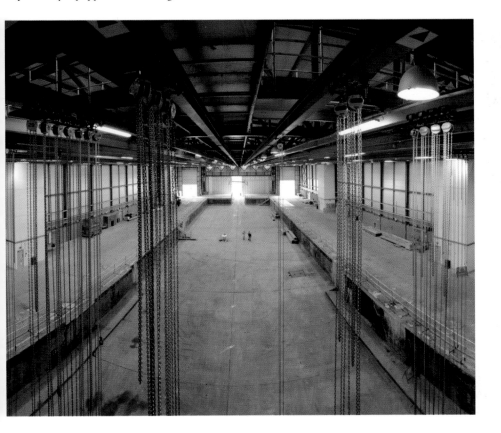

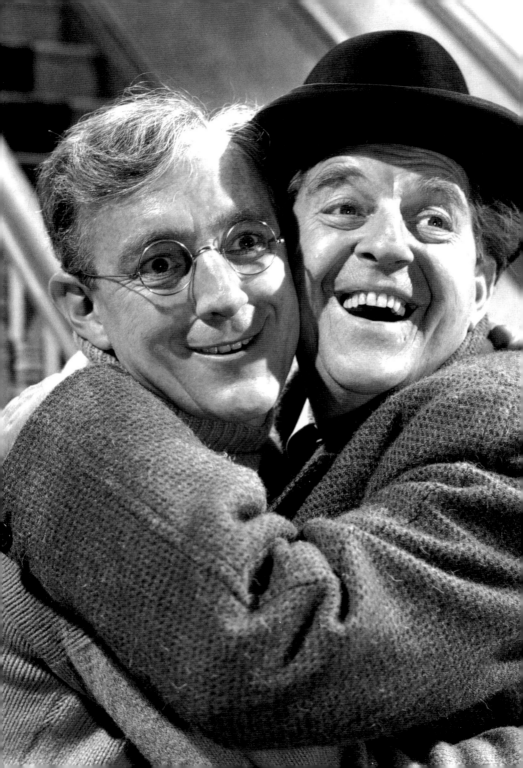

EALING: COMEDIES

THERE HAS BEEN A FILM STUDIO in Ealing since 1902, when Will Barker chose it as the new location for his Autoscope Company. He moved to Ealing, renamed his company Barker Motion Photography and built an impressive three-stage permanent glasshouse studio there. It has been argued that Ealing may be the oldest continuous location for film production in the world.

Barker became known for his historically inspired fiction films, including *Henry VIII* (1910), *East Lynne* (directed by Bert Haldane, 1913), and *Sixty Years a Queen* (also directed by Haldane in 1913). *Sixty Years a Queen* cost £12,000 to make, and G.B. Samuelson helped to produce and finance it. The film was hugely popular and as a result helped not only Barker in Ealing but also Samuelson, who used some of the profits to found his own studio at Worton Hall.

After Barker retired in 1918, Ealing became the location of the first purpose-built sound studio. In 1929 theatre director Basil Dean formed Associated Talking Pictures, and construction of the new studio was finished in 1931, on almost the exact site of Barker's earlier studio.

The 1930s were a busy period of production for Ealing, and the studios churned out films. Roughly half of these were made by ATP, which made pre-war stars of George Formby and Gracie Fields. The rest of the studio output was made up by other film production companies renting the studio stages. During the Second World War Ealing was one of only three major film studios to continue civilian film production. The studio was joined by directors from the Crown Film Unit, and a series of well-regarded films was made, reflecting the wartime experiences of ordinary people. George Formby and Will Hay, Ealing regulars, turned their talents to propaganda films. Notable films include Alberto Cavalcanti's extraordinary *Went the Day Well?* (1942) and Paul Robeson's last British film, *The Proud Valley* (1940).

One of the most famous production companies to make occasional use of the additional facilities at Ealing was Gainsborough, at that time headed by Michael Balcon. Basil Dean's ATP was floundering by 1938, so Michael Balcon

Opposite:
This shot from *The Lavender Hill Mob* (1951) shows two of Ealing's best-known stars, Alec Guinness and Stanley Holloway. Guinness's Henry Holland, a plotting bank clerk, and Holloway as his co-conspirator Alfred Pendlebury, are typical of the quirky characters with suspect morals that populate many Ealing comedies.

The 'White Lodge' is one of the remaining original buildings of Ealing Studio. The site was originally used for filming by the film pioneer Will Barker, who bought the lodge in 1902.

took over at Ealing and led the next period of the studio's development. Balcon embarked on a mission to make 'films projecting Britain and the British character' (as he wrote on a plaque erected at Ealing studio when it shut in 1955). To mark this change, the name ATP was phased out and Ealing became a production company name as well as a studio. From this point films made at the studio were known as Ealing Films.

At Ealing, Balcon could exert direct control, exclusively employing an established company of writers and directors, who were accorded considerable autonomy because their basic viewpoint was the same as his own. Balcon had very clear ideas about how he wanted 'his' studio run, but, like so many studios in the late 1940s, Ealing made a deal with J. Arthur Rank. Luckily Balcon managed to broker an agreement that accepted financial backing and distribution deals from Rank while maintaining complete autonomy to make Ealing films on his own terms. The deal was struck in 1944: Rank agreed to provide at first 50 and later 75 per cent funding, and a distribution deal that guaranteed screenings in circuits of British and American cinemas. The combination of Rank's money combined with Balcon's leadership led to a famously productive period for Ealing – giving the studio creative independence but with practical support.

Ealing had, until the late 1940s, made a wide range of films, dabbling in many different genres, but is now remembered for a series of films known collectively as the 'Ealing Comedies'. This brand name is usually used to refer to a small list of films made between 1947 and 1955, ignoring other comedies made at the studio, including many starring George Formby, Gracie Fields or

THE TRUE EALING COMEDIES

Hue and Cry, 1947	*The Man in the White Suit*, 1951
Another Shore, 1948	*Meet Mr Lucifer*, 1953
A Run for Your Money, 1949	*The Titfield Thunderbolt*, 1953
Kind Hearts and Coronets, 1949	*The Maggie*, 1954
Passport to Pimlico, 1949	*The Love Lottery*, 1954
Whisky Galore!, 1949	*The Ladykillers*, 1955
The Magnet, 1950	*Who Done It?* 1956 (Sometimes classified as a
The Lavender Hill Mob, 1951	'true' Ealing Comedy; sometimes not.)

Will Hay. It is arguable why this is the case, but the often sophisticated satirical humour of the classic Ealing Comedies has not dated as badly as the naïve simplicity of pre-war comedies starring music-hall stars like Fields and Formby.

Balcon's mission, to make British films about British culture for British people, was perfectly timed. The war had led the Government to realise how valuable films could be in building the nation's morale and boosting confidence in British culture. The Ealing Comedies featured ordinary British people with the odd eccentric thrown in. These films did not star the matinée idols championed by Rank's other studios, but quirky character actors such as Alec Guinness and Peter Sellers. Balcon himself described them as 'films about day-dreamers, mild anarchists, little men who long to kick the boss in the teeth'.

Kind Hearts and Coronets (1949) is remembered for Alec Guinness's performance in eight different roles – something Peter Sellers would emulate for his multiple-role turn in *Dr Stangelove or: How I Learned to Stop Worrying and Love the Bomb*.

They were a huge contrast to the glitzy Technicolor films being made at that time in Hollywood. The post-war public welcomed the uniquely British humour of the Ealing films and as the country rebuilt itself in the late 1940s these comedies became hugely popular. The strength of the 'Ealing' brand was such that two further 'Ealing' films, *Barnacle Bill* (1957) and *Davy* (1958), were actually made at Elstree.

What makes the Ealing Comedies so unusual is their variety. Unlike other British series, such as the Doctor films, or the Carry On films, the Ealing Comedies were all quite different. They were made by a core team of production staff, crew and actors, but the storylines ranged from the heist movie plot of *The Lavender Hill Mob* to the black comedy (and acting genius of Alec Guinness) in *Kind Hearts and Coronets* and the childhood adventure of *The Magnet*. Films such as *Passport to Pimlico* and *The Titfield Thunderbolt* showed local people coming together to protect their community – themes that must have tuned in to the

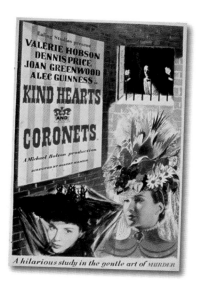

Whisky Galore! was a 1949 film set on the Scottish island of Eriskay. Its true story about a small community coming together to help each other is typical Ealing Studio fare.

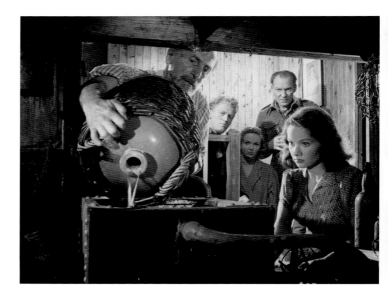

recently felt 'wartime spirit' experienced by their audiences. It is also worth noting that *Another Shore*, *Whisky Galore!* and *A Run for Your Money* featured Irish, Scottish and Welsh themes or characters – so Ealing was truly British, not just English.

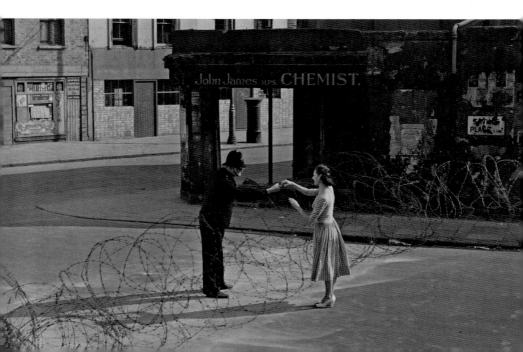

How did Ealing produce a series of films that had such a recognisable style and quality? The studio buildings themselves were part of this. Ealing was physically small and, unlike other studios, had no great ambitions to expand and update. The small group of buildings made a relatively low number of films each year, usually between four and seven features. Michael Balcon, having gained years of experience at other studios, was keen to foster a stable and family-like atmosphere. He branded the office walls with the slogan, 'The Studio with the Team Spirit'.

Interviewed in 1951, Robert Hamer (a regular Ealing director) commented:

> We are given complete liberty to follow our personal inclinations in choosing and elaborating our subjects. This seems to me a very important point. Apart from this the explanation may lie in the fact that we all – as it were – belong to the same film generation and consequently have the same general approach. We have all started in Ealing and have shared the same experiences for at least five or ten years.

Ealing was not a lucrative place to work – it did not pay high wages – but the combination of job security and the friendly atmosphere meant that the same production staff and crew were employed for many years. Balcon never underestimated how important it was for studio staff to stay happy, and every week he invited producers, writers and directors to talk with him around a large round table.

Opposite, bottom: Made in the same year as *Whisky Galore!*, *Passport to Pimlico* also features a community, in this case declaring itself independent of the rest of Britain. It starred Margaret Rutherford, Stanley Holloway and Barbara Murray. Here Barbara Murray (playing Shirley Pemberton) and Philip Stainton (as PC Spiller) talk over the barbed wire 'border' between Pimlico and the rest of London.

Michael Balcon liked to run Ealing as a studio with 'team spirit', and he encouraged his writers and directors to discuss film ideas sitting at his famous round table.

The Man in the White Suit (1951) also starred Alec Guinness, this time as the inventor of an indestructible new material.

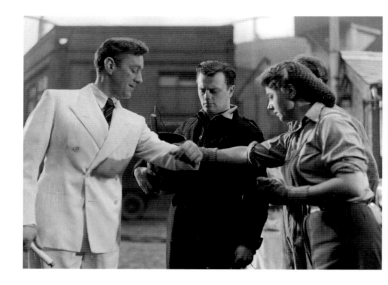

As Charles Barr comments in his book *Ealing Studios*:

In all, Balcon's name is on nearly a hundred Ealing features made … For most of this time, his staff remained substantially the same … The result was a set of films expressing a tight continuity over a period of twenty years.

Douglas Slocombe, the director of photography, lines Audrey Hepburn up for a shot alongside Alec Guinness on *The Lavender Hill Mob* (1951). At the time she was still relatively unknown.

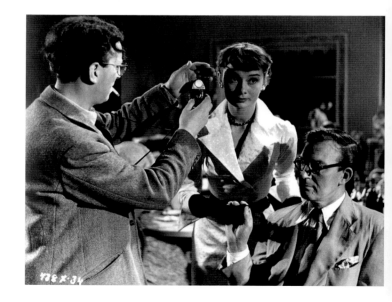

A look through the credits for the films made during Balcon's twenty-year tenure (1938–58) at Ealing will reveal clearly how consistent his studio staff list was. He employed a core staff of directors, including Charles Crichton, Basil Dearden, Charles Ford, Robert Hamer and Alexander MacKendrick, who each directed more than one Ealing Comedy.

Such was Balcon's popularity that a significant number of his regular employees and collaborators followed him to Elstree when production at Ealing ended in 1955. It is clear that a major contributing factor to Ealing's success was Balcon himself – he inspired loyalty among the staff he employed. He was a good businessman but had the imagination to give his screenwriters and directors the freedom they needed to make films they personally cared about.

Like the two other 'genre' studios, Hammer and Gainsborough, Ealing Comedies utilised a core group of actors who, while not signed up to any exclusive contract, did become associated with the studio. Alec Guinness, Alastair Sim, Stanley Holloway and Raymond Huntley all worked on more than one Ealing film. Among the most memorable Ealing performances is Alec Guinness's tour de force in playing eight different members of the D'Ascoyne family in *Kind Hearts and Coronets* (1949).

In this shot from *The Ladykillers* the gang looks over its loot. The cast included many Ealing regulars, and Peter Sellers and Herbert Lom would star together again, in the later Pink Panther series.

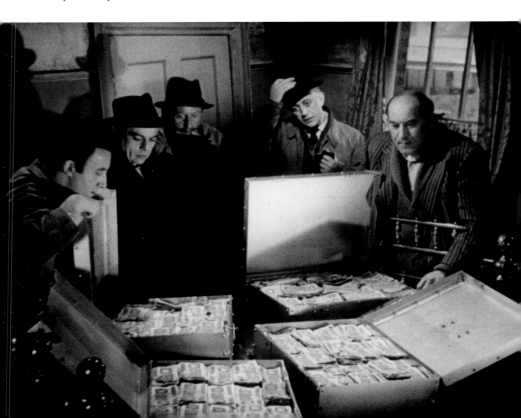

The director Alexander Mackendrick chats to three of his actors, Danny Green, Alec Guinness and Peter Sellers, on the set of *The Ladykillers*.

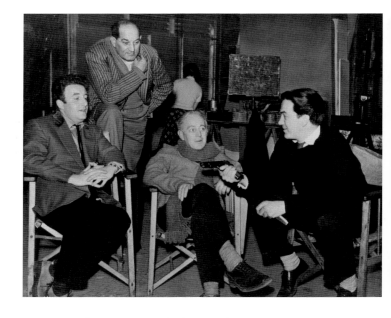

This publicity shot shows Peter Sellers in costume for *The Ladykillers* (1955). It was one of his first memorable roles.

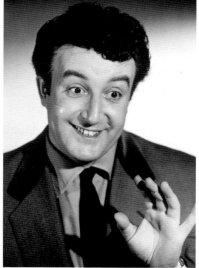

Many other actors worked on Ealing Comedies quite early in their careers: Audrey Hepburn had a small part in *The Lavender Hill Mob*; Carry On stalwarts Frankie Howerd and Charles Hawtrey worked on three Ealing Films between them; and Peter Sellers and Herbert Lom worked together on *The Ladykillers* eight years before they were reunited on *The Pink Panther*.

Unlike the Gainsborough Melodramas, Ealing Comedies have never waned in popularity. These days they are appreciated as gems of British film-making, and their enduring appeal has much to do with Balcon's preoccupation with trying to make films that dealt with British culture.

MICHAEL BALCON: AN OVERVIEW

During the 1930s British film production was guided by the vision of several individuals – men whose energy and ability to bring together the best creative talent made them as important to the industry as the actors and directors whose names are often more familiar to us. Michael Balcon is one of these visionaries, and his influence enabled first Gainsborough and then Ealing to become important studios of their era.

Balcon originally entered the industry in 1919, working in distribution rather than production. In 1921 he co-founded Victory Motion Pictures with his friend Victor Saville and in 1924 he and Graham Cutts founded Gainsborough Pictures. Balcon was to preside over the company for twelve years, as director of production for Gaumont-British from 1931. During his time there he gave Alfred Hitchcock his first directing job and went on to back several other Hitchcock films.

Balcon then took a chance to go to Hollywood, spending two not very happy years in charge of production for the British arm of MGM. Between 1938 and 1955 he was director and production chief at Ealing. In 1940 Balcon campaigned for film to be recognised by the Government as a potentially vital form of communication, urging:

> Let us at least acknowledge that the film industry is potentially of the greatest importance to this country, both commercially and culturally. The official recognition, which certainly does not exist today, would be half the battle if it were forthcoming. Let the film industry enjoy the faith and support of the Government, and you will find that it will flourish. Let the Government sufficiently recognise the potential value of the film as a weapon of war and so allow the industry to retain its technical personnel, give it facilities, let it have the supplies it needs, and it will flourish.

Balcon's talent lay in his ability to assemble creative teams of directors and technical crew, and his democratic 'teamwork' approach meant that talented people wanted to work for him and, having joined the Ealing team, tended to stay. Film-making, in the past and now, is a transient business, with teams usually assembled only for the duration of a single film – the consistency found in the Ealing crews is a testament both to the pleasant working environment of Ealing Studios, and the affection people held for Balcon himself.

While Balcon is most remembered for his involvement with the Ealing Comedies, his career both before and after that period was of great significance in the wider history of the British film industry. In 1959 he formed Bryanston Films and, when it was declared bankrupt in 1963, went on to take control of British Lion. He served as chairman of the British Film Institute production board and was knighted in 1948.

Sir Michael Balcon was a figurehead of the British film industry. At different times he was involved in Gainsborough, Ealing and Shepperton studios.

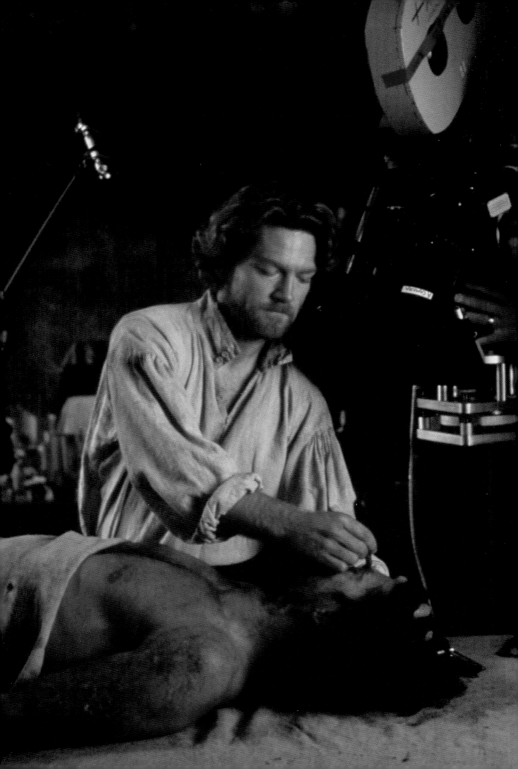

SHEPPERTON

IN 1928, shortly after the Cinematograph Act of 1927 boosted demand for British film production, Norman Loudon acquired a beautiful stately home, Littleton Park House, as well as 70 acres, including woodland and ¾ mile of the River Ash. Loudon had started out as a camera dealer, then moved into the production of moving photo flicker books. He recognised that the film industry was a worthwhile investment and in 1932 his new studio was ready. He called it Sound City Film Producing and Recording Studios. The name 'Sound City' clearly signalled his intention that his should be the most up-to-date studio – he made sure that it was equipped with all the latest sound-recording equipment. His modern facilities and spacious studio and back lot contrasted starkly with the older studios, many of which were crammed into inner London sites and were struggling to keep up with the need to modernise.

Shepperton's back lot was a strong selling point right from the start. Loudon built semi-permanent outdoor street and village sets that visiting film-makers could use without the need to spend money building their own. Early productions included *Three Men in a Boat* and *Drake of England* – both made use of the river running through the back lot. Even in more difficult times this ¾ mile of river has provided a lifeline to the studio – no other studio could offer the same, and many productions would come to Shepperton just to shoot their river scenes.

Loudon initially used the studio for his own film productions and rented space to other film-makers when his production schedule allowed for it. In 1935 he shut the studios in order to invest even more capital in expanding and improving the facilities. When he reopened in 1936, Shepperton 'Sound City' had seven air-conditioned stages. By this time Loudon had changed the focus of his own business interests – he stopped producing films of his own and concentrated on renting Shepperton out. Over time Shepperton became the studio of choice for independent film producers and many of them opened offices at the studio. Loudon had reopened just in time, because 1937 was a particularly busy year; twenty-five films were made, many of them 'quota quickies'.

Opposite:
Kenneth Branagh shot *Mary Shelley's Frankenstein* (as actor and director) in 1994 and most of his Renaissance Pictures films have been shot at Shepperton. (See page 73)

However, that busy period was not to last. By 1938 other studios were in trouble and Shepperton too had empty stages. In 1939 just five films were produced before war was declared, and, like many other studios, Shepperton was requisitioned. Although some art department staff found work making full-scale replica guns, planes, tanks and lorries used to confuse Luftwaffe bombers, the studio discontinued conventional film production for the duration of the war.

When Shepperton opened again after the war, it was very shortly under new management. Alexander Korda, whose own Denham Studios had been something of a financial disaster, took control of Worton Hall (G.B. Samuelson's old studio in Isleworth) in 1945 and, by buying a controlling interest in British Lion and Sound City Films Limited, took control of Shepperton in 1946. Worton Hall and Shepperton became closely linked, with many productions spread between both studios.

Looking through the memoirs of film-makers, it is difficult to find any negative comment regarding Alexander Korda. Despite his roller coaster

This aerial view of the Shepperton reveals its unique setting near the reservoir. The areas now covered with housing were once part of the studio back lot.

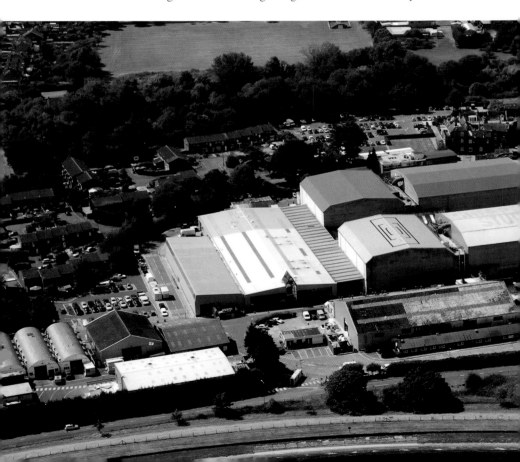

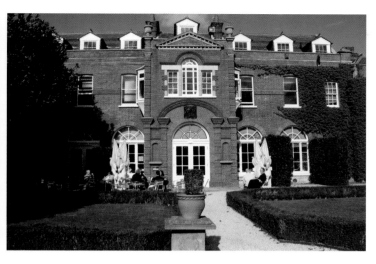

Littleton Park House was at the centre of the site Norman Loudon purchased for his studio, and it is still used as a filming location today.

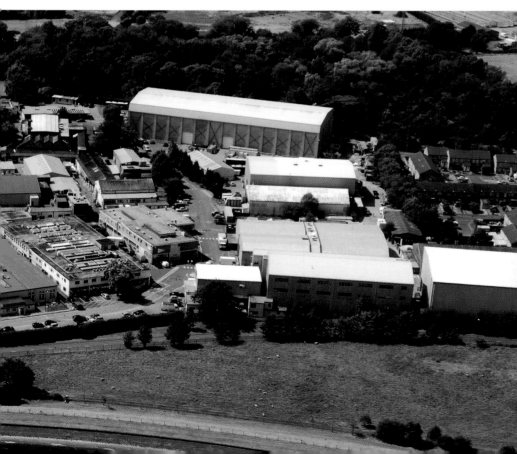

finances, Alex, as he was always called by those who knew him, seems to have been universally liked and admired.

People working at the studios he ran appreciated the fact that their studio head was a film-maker himself. While Denham was somewhat disastrous, by giving up his position there Korda was able to take a more active role in film-making once again. At Shepperton he often directed low-budget films without ever taking a credit – he was a highly proficient director who was just as able to command a sound stage as he was a boardroom.

One of the long-term contrasts between Pinewood and Shepperton has been the style of management. Pinewood was run by Rank, who hired efficient studio managers who were businessmen but not film-makers; Shepperton at different times was run by Korda, the Boulting brothers and more recently the Scott brothers, all film-makers keen to make their studio the best for making films, and not simply as a business concern.

By 1948 Rank had built up huge debts and decided to introduce drastic measures in order to survive. They started dramatic cost-cutting, and creative directors who had previously been left to make their films without too much interference from Rank management found themselves under pressure to make films as fast and cheaply as they could. This policy ultimately led to film-makers breaking out from the Rank organisation to produce films independently, and Shepperton, as the home to independent film-makers, could only benefit.

The government was keen to help preserve the British film industry, and in 1948 the National Film Finance Company was formed. Korda, always so clever at raising funds, secured a £2 million loan for British Lion. Korda also had plenty of useful contacts in Hollywood. He struck a multi-picture deal with Hollywood producer David O. Selznick, who would provide some finance and also Hollywood stars in return for the American distribution rights. In 1949 one of Shepperton's best-known films was produced, *The Third Man*. Directed by Carol Reed and starring Orson Welles and Joseph Cotton, the film was shot at both Worton Hall and Shepperton as well as on location.

Changes at Rank also saw Michael Powell and Emeric Pressburger (under their production company The Archers) move from Pinewood to join Korda at Shepperton. Powell and Pressburger had met at Denham through Korda and they went on to produce several films at Shepperton, starting with *The Small Back Room* in 1949. Carol Reed and David Lean added to the list of notable directors filming at Shepperton – the studio had become a haven for some of Britain's biggest talents.

However, in 1950 British Lion incurred production losses and was in financial trouble again. In 1954 the NFFC called in their loan and the receivers replaced Korda with a temporary manager. This could have

been disastrous, but when the company was re-formed as British Lion Films Limited in 1955 the focus had changed from film production to the provision of distribution and financial guarantees for independent producers. Shepperton's role as a studio for independents had been recognised and strengthened.

The managing director of the NFFC, David Kingsley, became the director of the studio in 1955, and managing director in 1958. Joining him was a new board of directors, including the independent film-makers Frank Launder, Sidney Gilliat, and identical twins Roy and John Boulting. As film-makers themselves, they would all make films at the studio in the following years, and Shepperton contrasted even more starkly with its greatest rival, Pinewood, which under John Davis was at this time being run more like a film factory than a creative enterprise.

Carol Reed shot much of *The Third Man* on location, but owing to Orson Welles's busy schedule all of the studio filming was achieved at Shepperton in a very short time.

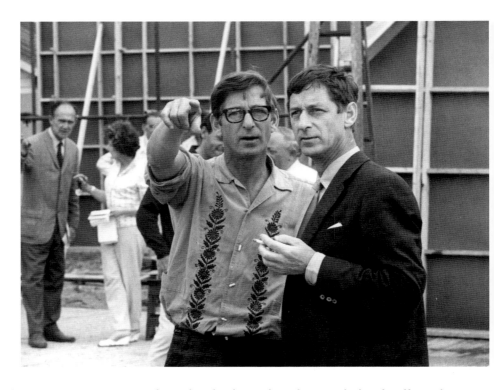

The identical Boulting twins John and Roy, gained valuable experience in the AFPU and RAF Film Unit during the war before becoming important figures at Shepperton.

Pages 68–9: In this production shot from the musical *Oliver!* (1968) it is possible to get an idea of the huge scale of the sets built on the studio back lot.

The Boulting brothers, John and Roy, made their first film at Shepperton in 1950, so they knew the studio well by the time they became involved at management level. The twins usually worked as a producer/director team, alternating the roles on different films. Starting with *Private's Progress* in 1956, they became known particularly for a series of comedies, often featuring a regular group of cast members, including Ian Carmichael, Terry-Thomas and Richard Attenborough (who would later become more involved in the history of Shepperton, as a director).

The year 1957 saw the instigation of the Eady Levy, a tax on cinema takings that would be pumped back into the industry to subsidise film production directly. It was also an important year for Shepperton, because a Basil Dearden film called *The Smallest Show on Earth* brought a young actor, Peter Sellers, to Shepperton for the first time. Sellers was to make many of his best-known films at Shepperton.

Having managed to survive until the end of the 1950s, Shepperton became much busier in the 1960s. Long-running series, such as the St Trinian's films and the Boultings' comedies, continued. The Pink Panther series started in 1963, the same year *Billy Liar* established Julie Christie as

one of Britain's most exciting talents. The range of films was diverse, with small, low-budget films as well as bigger productions such as *The Guns of Navarone* and Disney's *Greyfriars Bobby* all shooting at Shepperton.

In 1963 Stanley Kubrick was looking for the right studio to shoot his new film. He had made *Lolita* at Elstree and knew that he was happy making films in England. When Peter Sellers signed up, the decision was final, because he was in the middle of a divorce and would not leave England. *Dr Strangelove or: How I Learned to Stop Worrying and Love the Bomb* was to prove a challenge for everyone involved. Columbia Pictures had agreed to finance the film only if Peter Sellers would act in at least four lead roles, but in the end he played only three, giving up on Air Force Major T. J. 'King' Kong because he felt an authentic Texan accent was beyond him.

Kubrick hired Ken Adam as his production designer. Adam would become famous for his James Bond sets, and his designs for *Dr Strangelove* were no less ambitious. The wonderfully sinister War Room set featured

Kubrick's *Dr Strangelove or: How I Learned to Stop Worrying and Love the Bomb* (1964) featured amazing sets by Ken Adam. In this shot Peter Sellers recovers from a cake fight scene which was ultimately cut from the film.

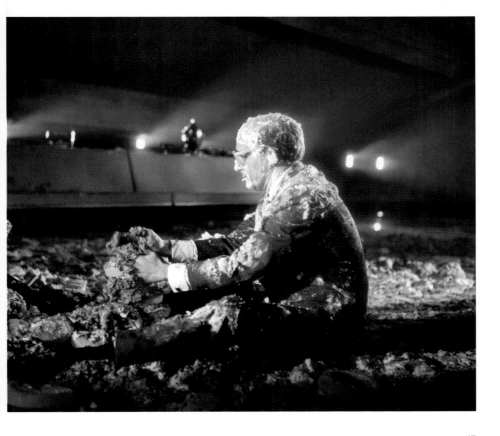

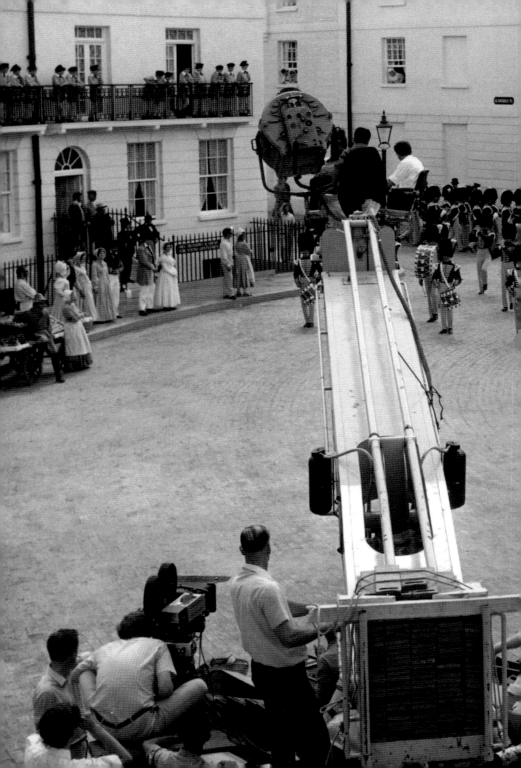

glossy black floors, so, in order to preserve the finish, crew and cast wore felt overshoes much of the time. Kubrick was keen that his actors should be lit by the huge chandelier alone, so the set was tweaked until this was accomplished. Despite its controversial storyline, the film was a huge success. Ken Adam won a BAFTA and both Kubrick and Sellers were nominated for Academy Awards.

While 1963 was a good year for films, it marked yet another crisis in the management of the studio. The NFFC still owned a stake in Shepperton, and they initially decided to buy out the film directors who had become involved in the late 1950s. In the end Sir Michael Balcon, ever the champion of British film-makers, led a successful consortium that bought British Lion and Shepperton. Balcon himself was of the opinion that the best people to run British Lion were already running it, so his team included all five of the original directors. At the studio, for the moment at least, life continued as usual.

Another hugely successful film for Shepperton was *Oliver!* It was shot by veteran director Carol Reed (who made a significant number of his films

The affair and subsequent marriage of Elizabeth Taylor and Richard Burton captured the public's imagination and Taylor frequently visited Burton on whatever film he was involved in. Here they relax with Peter O'Toole near the catering wagon on *Becket*.

at the studio), with cinematographer Ossie Morris. Made in 1967, this bright and colourful musical is now considered as much of a classic as David Lean's more traditional 1948 film *Oliver Twist*.

Unfortunately the stability Michael Balcon and others had secured for the studio was very short-lived. In 1971–2 British Lion posted a loss of £1million and a banker named John Bentley set his eyes on the company. His intention was to 'slim down' the studio, and sell off a significant proportion of the valuable back lot for property development. After a complicated series of campaigns and different development proposals, in 1973 Shepperton was dramatically changed for ever.

Loudon's magnificent studio was cut down to eight stages on a far smaller studio lot. The permanent studio staff were made redundant and Shepperton (like other studios trying to survive at this time) went 'four wall'. The term 'four wall' is used in the industry to describe productions that hire just the four walls of the studio, with no use of studio-employed film crew. Now film productions using the studio would bring in their own freelance crew. Parts of the studio were hired to different companies and at one stage The Who were major shareholders in a company that leased two stages and the old house. At that time it must have been hard to imagine that Shepperton would ever be a success again.

Cameraman Peter Hannan and pop star star Mick Jagger work on *Performance* (1970).

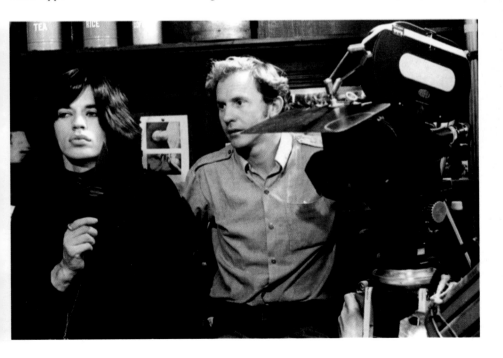

Margaret Thatcher's government (from 1979 onwards) nearly destroyed the industry altogether, ending the quota scheme first established by the Cinematograph Act of 1927, abolishing the Eady Levy and also removing the tax incentives, all of which had helped British film-making.

In the late 1970s and early 1980s Shepperton went through a series of owners, and was badly maintained. When Ridley Scott chose to film *Alien* there in 1978 it was one of just seven films made at Shepperton that year. Much of the studio was in disrepair but the lack of other clients meant he could build enormous sets on several stages. Scott has said:

When Ridley Scott shot *Alien* in 1978 the studio was virtually empty and in bad repair, but this gave him the freedom to build the huge sets needed for his film. Here he directs Sigourney Weaver as Ripley.

> What did trouble me was the decline of Shepperton in the 1970s as the British film industry took one of its many knocks over the years. The studios started to resemble a shabby uncle – much loved but in need of some care and attention. I carried on working there regardless, because I don't give a damn whether a studio is decrepit or not.

In 1984 another pair of brothers, John and Benny Lee, bought the studio and invested some money in much-needed renovations and improvements. In the same year veteran director David Lean returned to make *A Passage to India*, his last film. Television production at the studio also expanded, and helped to keep the place going at a quiet time for film production.

Cinematographer Mick Coulter takes a moment between shots with the stars of *Sense and Sensibility* (1995), Emma Thompson and Kate Winslet.

In his career as a director Richard Attenborough has chosen to shoot a significant number of his films at Shepperton. Here he directs Robert Downey Jnr on his 1992 film *Chaplin*.

The actor/director Kenneth Branagh has directed most of his films at Shepperton, starting with *Henry V* in 1988. He has said of the studio: 'You walk into the studio sometimes and think, from here you can create any world you want, indoor or outdoor. That sense of magic being created is very strongly present at Shepperton.' With his production company Renaissance Films, he made four films at Shepperton between 1989 and 1996.

One of Branagh's most ambitious projects was his 1995 adaptation of *Mary Shelley's Frankenstein* (see page 60). He cast Robert De Niro as Frankenstein's monster and, shooting the whole film at Shepperton, he required what was at the time the largest set ever constructed at a British studio. The Ingolstadt/University set recreated eighteenth-century Bavaria and was built using the entire Shepperton back lot.

Having become a long-term patron and one-time owner of the studio, Ridley Scott chose to return to Shepperton to make his long-awaited *Alien* prequel, *Prometheus*, in 2011.

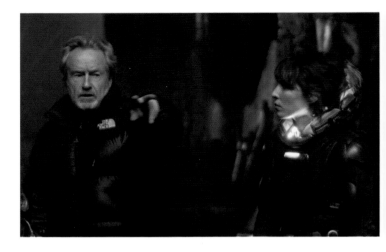

When Christopher Nolan set about shooting his first Batman film in 2005, he used the huge stages available at Shepperton for some of his important sets. Here he directs Christian Bale and Ken Watanabe.

Also in 1995, the Scott brothers, as part of a consortium, bought Shepperton. Once again the studio was owned and run by film-makers rather than businessmen. They renovated the studios and the 1990s brought a revival of the British film industry that has thankfully continued (with a few blips) year on year.

Just as films made by the Boulting brothers or Balcon's Ealing Studios created a specifically British style of film, more recently Working Title has done the same thing. Based at Shepperton, Working Title produced *Four Weddings and a Funeral* in 1994 and it eventually made $245,700,832 worldwide. That success led to a whole series of very British films, including *Notting Hill*, *Billy Elliot*, *About a Boy* and *Love Actually*, all made at Shepperton.

In 2010 Martin Scorsese joined the long list of eminent American directors who have chosen to shoot at Shepperton. His film *Hugo* used the studio to recreate the Paris Metro as a large-scale set. When Scorsese was awarded the BAFTA Academy Fellowship in 2012, he used his speech to sum up exactly why great directors still make their films in British studios:

The top American directors have always shot at British studios and Martin Scorsese recreated the Paris Metro at Shepperton for his film *Hugo* (2011). Here he directs his young stars Chloe Moretz and Asa Butterfield.

The rich tradition of British cinema also embraces for me the fearless craftsmanship of the British crews who helped me with dedication and extraordinary imagination when making the film *Hugo* here at Shepperton – a film of which all of us who worked on it can, I hope, be proud ... I am particularly honoured to have worked alongside them, as I am to be here holding this award.

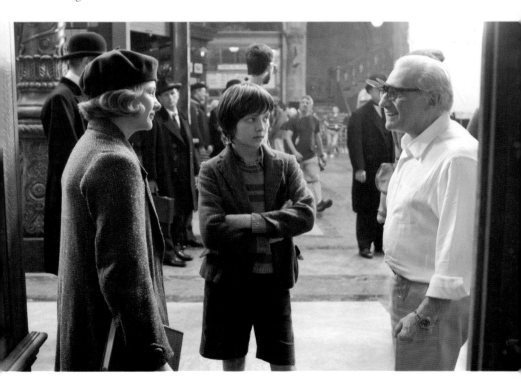

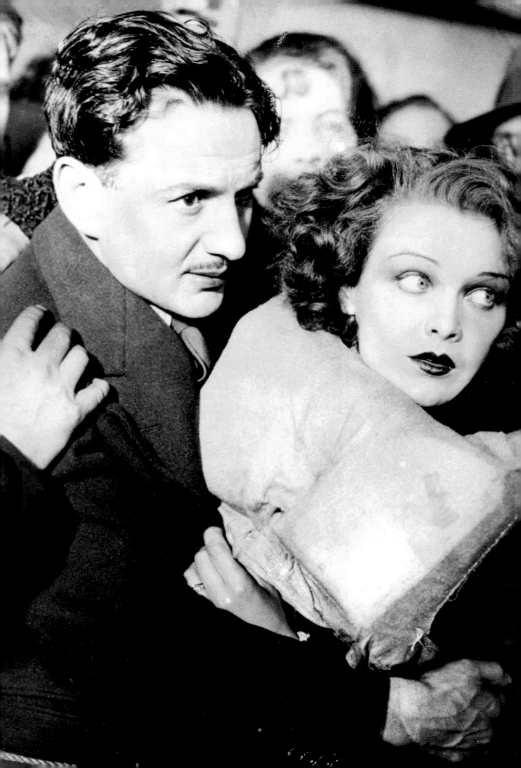

ELSTREE: A BRITISH HOLLYWOOD

THE ELSTREE AND BOREHAMWOOD area has been home to a number of different film studios since 1914. Several of the studios existed at the same time, and as one company went bust and another took over the names of each studio changed over time. This makes it very challenging to cover the whole history of the area that was to become known as the 'British Hollywood'. 'Elstree Studio' is often used as a generic term, and usually refers to either of the two biggest studios there, Amalgamated/MGM or BIP/ABPC/EMI.

Elstree was identified as the perfect location for a studio by Percy Nash and John East, who had met at the London Film Company in Twickenham. Elstree was near London without being fog-bound. At this time Greater London alone had four hundred cinemas and many small film studios had been created in converted buildings – but as the demand for film production grew, these makeshift studios needed to be replaced by purpose-built facilities. Convinced that they could produce films more efficiently, Nash and East managed to drum up investment to build a studio from scratch and named their new company Neptune Films. When the studio opened in 1914 it was the first fully dark stage in Europe.

Although they enjoyed much early success, the unfortunate timing of opening the studio at the start of the First World War did eventually catch up with Neptune. Efforts by the Government to boost the British film industry (via the Amusement Tax – which invested a small percentage of cinema ticket takings back into film production) failed and the Americans easily dominated the British box office. By 1917 the company had gone bust. However, in 1928 the Blattner Film Corporation would start operating in the former Neptune studio and nearby the Whitehall Studios were established.

By 1925 Hollywood was booming and the British studios were struggling to keep up. American film entrepreneur J. D. Williams decided Elstree would be the perfect location to establish a 'British Hollywood'. Williams joined forces with W. Schlesinger and Herbert Wilcox to build a new studio there (British National Studios), but the partnership quickly foundered.

Opposite: *Atlantic* was shot at Elstree's BIP studio in 1929, just on the cusp of the sound revolution. It had soundtracks recorded in English and German, but the acting style was still evolving from the melodramatic gesturing of silent cinema. Here Madeleine Carroll and John Stuart play lead roles Monica and Lawrence.

ELSTREE TIMELINE

The table above
shows as
clearly as
possible the
history of
each studio.

Instead, the brand-new studio was sold in 1927 to a Scotsman, John Maxwell, and the studio (which would be known as the 'Porridge Factory' after its Scottish owner) was opened. Its official name was British International Pictures (or BIP, later to become the Associated British Picture Corporation, ABPC).

Maxwell already had fifteen years of film industry experience under his belt and believed that the way forward was for production, distribution and exhibition to be linked. It was this model that J. Arthur Rank would later use to dominate the British film industry.

Maxwell was an astute businessman. His new studio had the best facilities, and he went about recruiting a talented array of permanent studio staff. One of his most significant decisions was to hire Alfred Hitchcock on a three-movie deal. Maxwell equipped his new sound stages with RCA Photophone equipment and as a result Britain's first sound feature, *Blackmail*, was made at Elstree. The first full-length talkie, *Atlantic* (the first sound film about the *Titanic*), by E. A. Dupont (1929), was also shot there.

The 1930s was an important period of expansion for the development of the studios in Elstree. In 1935–7 Elstree's other big studio was completed. It was built as the Amalgamated Studio, but the original company went bust and the studio was sold to Rank – further expanding that company's film empire.

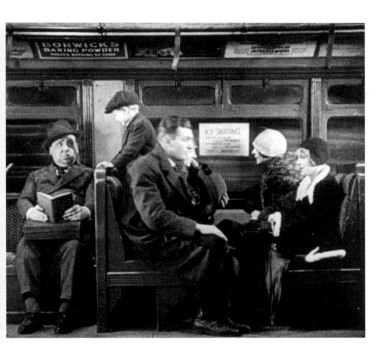

Hitchcock is famous for always making a cameo appearance in each of his films. This is him (left) in *Blackmail* (1929).

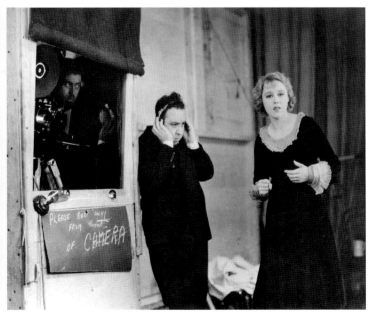

When Hitchcock shot *Blackmail*, the camera had to be surrounded by a cabin so that the sound recording would not be ruined by the sounds of the camera running.

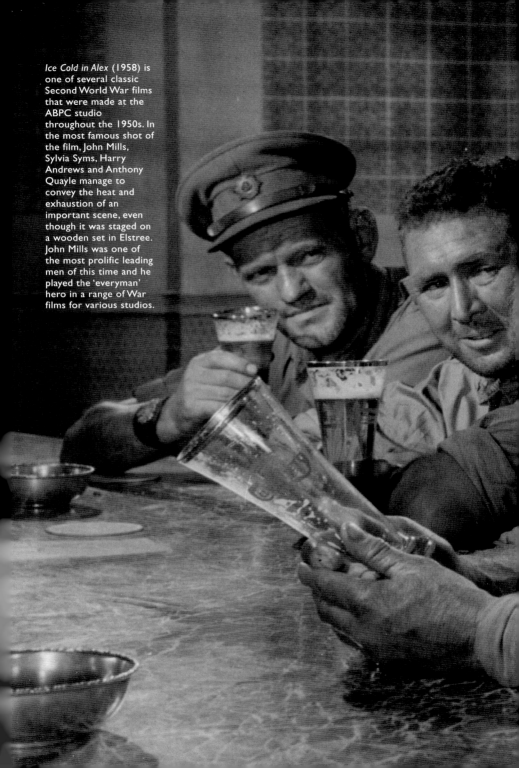

Ice Cold in Alex (1958) is one of several classic Second World War films that were made at the ABPC studio throughout the 1950s. In the most famous shot of the film, John Mills, Sylvia Syms, Harry Andrews and Anthony Quayle manage to convey the heat and exhaustion of an important scene, even though it was staged on a wooden set in Elstree. John Mills was one of the most prolific leading men of this time and he played the 'everyman' hero in a range of War films for various studios.

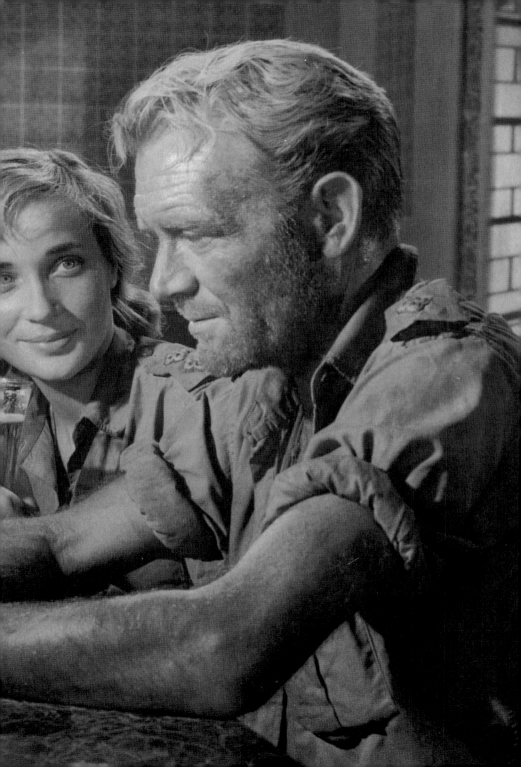

Herbert Wilcox, one of the three entrepreneurs who had built Maxwell's studio, had moved into a studio of his own next door, known as British and Dominions (B&D). Tragically a fire destroyed the B&D Studios site in 1936 and shortly afterwards the remaining Elstree studios were requisitioned, like many others, for alternative use during the war.

In 1946 Warner Bros acquired an interest in ABPC and spent two years improving the studio facilities before going back into production in 1948. Whilst Warner Bros had invested in ABPC, in 1945 another American company, MGM, invested in the other big Elstree studio, Amalgamated. The MGM studio did not go into production till 1947, but by the end of the 1940s the two large studios at Elstree boasted some of the biggest and best-equipped sound stages in the country. They were joined, in 1956, by one last Elstree studio, Danziger. The Danziger studio existed only until 1962, and although it produced some films it was also used for television production. Most of the Elstree studios were involved in television production to some extent, and in the first few years television production was not so different from film, because shows were shot on 35mm film. From the 1960s the Neptune site was converted to television production only and it still exists as the BBC Elstree Television Centre.

Through the 1950s the Elstree studios turned out a range of films, including the ABPC classics *Ice Cold in Alex* and *The Dam Busters*. MGM-British made *Lucky Jim* in 1957 and then kept busy through the 1960s with a varied slate of films including *Quatermass and the Pit* (1967), *The Dirty Dozen* (1967) and *2001: A Space Odyssey* (1968). Also in 1968, the old ABPC studio was rebranded as EMI Elstree.

British film crews working in the 1960s and 1970s benefited from the almost matchless training the British studios had offered people entering the industry from the 1920s through to the 1950s. Teenage boys, often straight out of school, would start work at the studio as a runner or post boy. The studio would then place them with different departments, allowing them to see how the whole studio worked, before they chose the area in which they wished to make a career.

Having chosen a department, young trainees would work their way up through the grades. The British film crews gained an international reputation for being good, because their training gave them range and depth of experience. Working as a runner or post boy enabled a trainee to gain insight into how other departments worked and how the studio worked as a whole.

Because British film studios employed crews on permanent contracts, they offered stability and long-term prospects. It was perfectly possible to spend one's whole career working for a single studio, and frequently (as in other British industries of the time) several members of a family would work in the same department in the same studio. In Elstree many of the local people found work

at the studios. John Kirsop, who became a camera grip, recalls: 'My father ended up as a Building Supervisor up at MGM, three uncles were riggers at ABPC, two of my other uncles were stage hands. My brother-in-law was a top line editor, a very well known editor. And my sister was also a secretary to Stanley Donen, film director.' Veterans of the industry remember the studios as having a family atmosphere, where everyone knew each other for many years.

However, for many decades the film studios were very much under the control of the trade unions, and the electricians ruled the roost. Although unions are formed to help members improve working conditions, the system in the studios became crippling for film-makers. Overtime was virtually impossible to negotiate, and anyone wanting to get a job had to have a union ticket – but you could only get a union ticket by having a job – a 'Catch 22' situation that was hard to overcome.

When the studios changed to the 'four wall' system and ceased to employ their own permanent crews, freelance working became the industry norm. However, the older generation of film crew often carried on working in teams that originated in their past as studio employees.

The ABPC/EMI studio at Elstree had, like many others, employed a large permanent staff and been run under tight union rules. But from the

Kubrick's *2001: A Space Odyssey* (1968) was mainly shot at Elstree's MGM studio on futuristic and highly detailed working sets that would set the standard for science fiction films for many years to come.

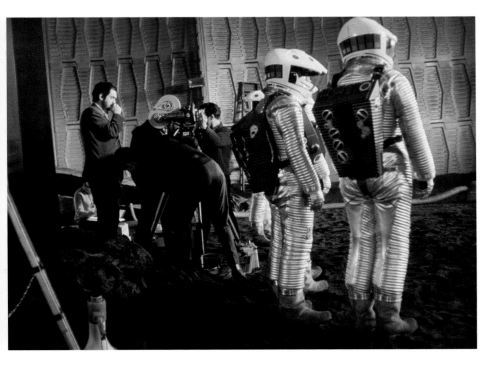

early 1970s onwards, as permanent crew were no longer employed, the unions lost their tight hold and things began to change. Crew who had once been studio staff became freelance.

Ron Punter, a scenic artist who worked on the Star Wars films, the Indiana Jones films, *Return to Oz* and *The Shining*, remembers:

> Basically we were all working together on five or six films, one after the other. It was a really good crew to work with because we were all friends by the time we got to the end. We knew everybody as friends from Spielberg and George Lucas downwards.

The start of the 1970s marked another significant blow to Elstree. MGM decided, with almost no notice, to shut down MGM Elstree. Some film historians have argued that *2001: A Space Odyssey* may have contributed to the demise of the MGM studio at Elstree, simply because Kubrick virtually took over the whole studio for two years, making it impossible to finance the studio by renting out additional stages to other productions. When MGM closed, what had been one of the industry's best-equipped and most loved studios was lost. As Mick Brady, a former MGM props man, remembers:

> It was a big blow, I think, to most of the people there, because it was so out of the blue. It just seemed to be one little item in the paper that MGM was in difficulties and they were going to sell their holdings in Europe. And the next thing we know, a couple of weeks later, we were all out of the gate and all gone. But it was a wonderful studio. You never ever wanted to have a day off.

Study of the overall history of studios in the difficult period of the 1970s and 1980s shows that what enabled some to survive was the loyalty of particular film directors. At Shepperton some of Britain's most notable film directors chose to make nearly all their films there. At Elstree, in the end the studio was largely saved by a series of American directors.

Kubrick filmed *Lolita*, *2001: A Space Odyssey*, *A Clockwork Orange* and *The Shining* at the two big studios in Elstree, Spielberg used EMI for his Indiana Jones films, and George Lucas decided that he would use it for all three parts of his original *Star Wars* trilogy. With larger studios such as Pinewood and Shepperton on hand, why did they return to Elstree? It may be partly because Elstree at that time was not too small, but not too large either. It meant that a director could almost completely take over the studio, making use of all available space. A film that really demonstrates this approach is *The Shining*. Kubrick used a group of adjoining sound stages, building corridors between so that the Overlook Hotel set, once finished, was a set

Opposite page:
The rotating wheel set built for *2001: A Space Odyssey* (1968) was a marvel of engineering that enabled Kubrick to mimic the weightlessness of space.

of real rooms linked together just as they would be in a hotel. Instead of cutting shots as actors moved from one set to the next, the camera could follow as if moving around a real building. The Overlook set was so large that Kubrick even converted some studio workshop rooms to become part of it. The maze set, built on the back lot, was a genuine maze, with crew members regularly

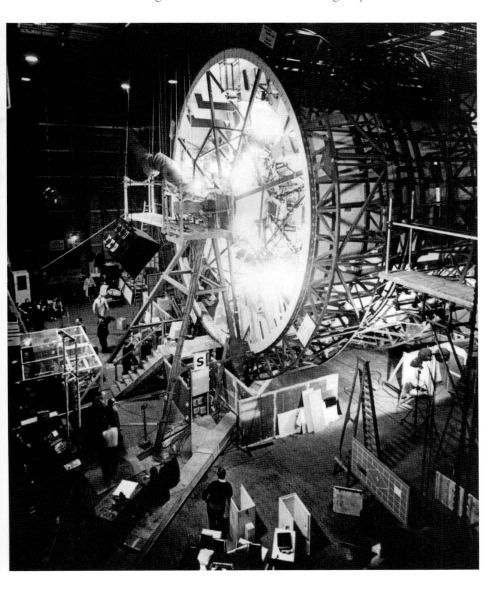

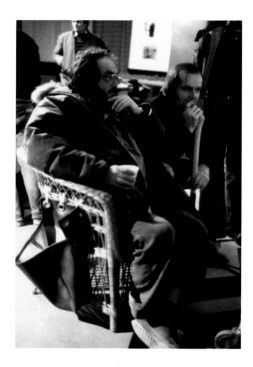

Kubrick and his star Jack Nicholson on the Overlook set that Kubrick built at the EMI studio for *The Shining* (1980). The set took over nearly the whole studio and near the end of the shoot burnt down as a result of the excessive lighting required to illuminate the space.

getting lost trying to find their director. As always on a Kubrick shoot, *The Shining* was a gruelling but creative experience for the crew and actors who worked on it. The shoot ran hugely over, partly because towards the end the main part of the Overlook set burnt down and had to be rebuilt.

By the late 1970s EMI's Elstree studio was the last surviving film studio of the 'British Hollywood', and like other British studios it was struggling to survive. Ken Russell's film *Valentino* was shot in Elstree in 1977, and in an article about a set visit to the film the journalist Herb A. Lightman wrote with some contempt:

We pass the ghostly hulk of what was formerly MGM's Borehamwood Studios, shooting site of many a cinematic triumph... now sadly serving as some sort of massive garage... but surely still shimmering with the shades of Kubrick's fabulous '2001'. Off to the left, a higgledy piggledy complex of sprawling structures... the venerable precincts of EMI Elstree Studios... more like some monstrous button factory than the sort of place where one might expect the magic of the early silver screen to be in the process of re-creation.

When George Lucas was searching for a studio in which to make his new film, *Star Wars*, he looked at many different locations. He needed somewhere cheap, he needed the use of several stages at once, and, as a relatively inexperienced director, he needed a talented crew. Elstree fitted the bill, and one of the deciding factors was that he could work with some of the crew who had made Kubrick's *2001: A Space Odyssey*.

Lucas took over the whole studio, and when *Star Wars* proved to be a huge success he based his sequels *The Empire Strikes Back* and *Return of the Jedi* there too. Having built a larger stage for *Empire*, Lucas had also improved Elstree's facilities, and Elstree was a natural choice when Lucas and his friend Steven Spielberg started their Indiana Jones series.

For *Raiders of the Lost Ark* Spielberg's sets moved in almost as soon as Kubrick's Overlook sets were down. His 'Well of the Souls' set was dressed with six thousand live snakes. The whole crew had to wear protective clothing, just in case. The crew was British, and included veteran director

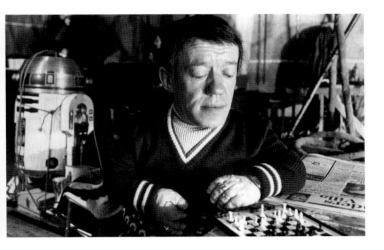

R2-D2 actor Kenny Baker takes a break from filming *Return of the Jedi* to play a game of chess.

of photography Douglas Slocombe, who went on to make two further Indiana Jones films. In a magazine interview at the time Spielberg said:

> Working with the British crew on *Raiders* was the best experience I've had working on a movie. From Norman Reynolds, the art director, and his

For *Return of the Jedi* (1983) the *Star Wars* cast reunited for the last time and completed the trilogy that had dominated the EMI studio at Elstree for several years.

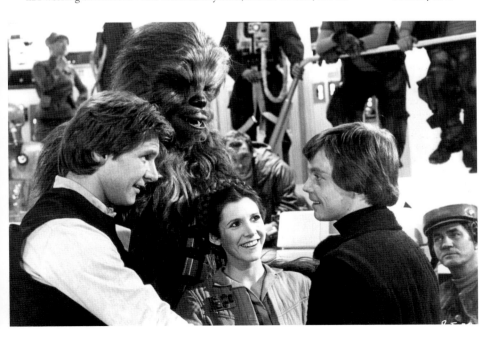

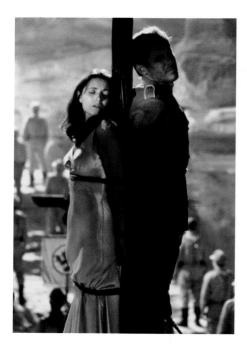
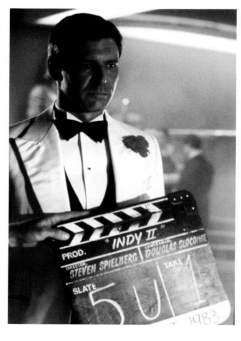

For *Raiders of the Lost Ark* (1981) Steven Spielberg built several huge sets on the sound stages that had only just been vacated by Stanley Kubrick. Harrison Ford starred with Karen Allen.

Above right: By the time Harrison Ford shot *Indiana Jones and the Temple of Doom* (1984) he was an Elstree veteran, eventually shooting all of the Star Wars films and all but the most recent of the Indiana Jones films there.

entire bunch, Doug Slocombe and his camera crew, to the 'chippies' and the 'sparks', it was absolutely fulfilling. There was no bitterness, no temperaments; everybody worked together to make a good movie.

Apart from the recent *Indiana Jones and the Kingdom of the Crystal Skull*, all the Indiana Jones films were shot at EMI Elstree.

One more American helped to contribute to the survival of production at Elstree – Jim Henson. His Muppets series was made there and he also chose to make his 1982 film *The Dark Crystal* there. Kiran Shah, a stunt actor who used to double the puppets for some sequences, remembers:

I worked on it for one year. It was the first time that anyone had done a complete puppet movie (no human characters were involved) and everyone was really excited. The atmosphere was very friendly and we were like a big family, working on a ground-breaking film using animatronics puppets for the first time.

Unfortunately, while there were directors keen to use the studio, at management level Elstree was in trouble by the early 1980s. EMI became Thorn-EMI and by 1985 the studio was for sale. From 1988 it was in

the hands of property developer Brent Walker, and, like Shepperton, lost a significant part of its back lot. At this point Paul Welsh, council officer and studio historian, with the help of the Elstree Studio managing director Andrew Mitchell, launched the 'Save Our Studio' campaign. The local community – which had benefited so much over the years from the studios – was quick to support the campaign.

Unlike other studios, set behind the high walls of the country houses they were built on, Elstree's studios were scattered through and around the small town of Borehamwood. The studios were and still are a part of the community. When films were being made in the past, fake snow would drift down the high street, actors would nip into local shops for their cigarettes, and half the town was working or knew someone who was working in one of the studios. In 1996 history was made when Hertsmere Borough Council bought the remaining studio. Elstree is now truly owned by its local community.

Elstree Studio today is small compared to the studios that once dominated the area, but it is once again a successful studio, employing locals and turning out award-winning films. Unlike any other British studio, it is owned by the local council, not by a private company. Through the efforts of the Elstree Screen Heritage project, with enthusiastic support from locals, Borehamwood High Street now celebrates the past of the 'British Hollywood'. Banners and information boards tell locals and visitors about the rich screen heritage of the town, from the station, where Whitehall Studios once stood, all the way up to the gates of the current studio.

With twenty-first-century films including *The King's Speech* and *Hyde Park on Hudson*, production looks set to continue in the studio that is now the only part remaining of the 'British Hollywood'.

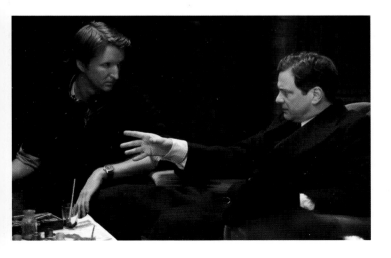

The King's Speech (2010) is just one of several successful films that have been shot at Elstree in the twenty-first century. Elstree Studio is once again doing well. Here Tom Hooper directs Colin Firth in a pivotal scene.

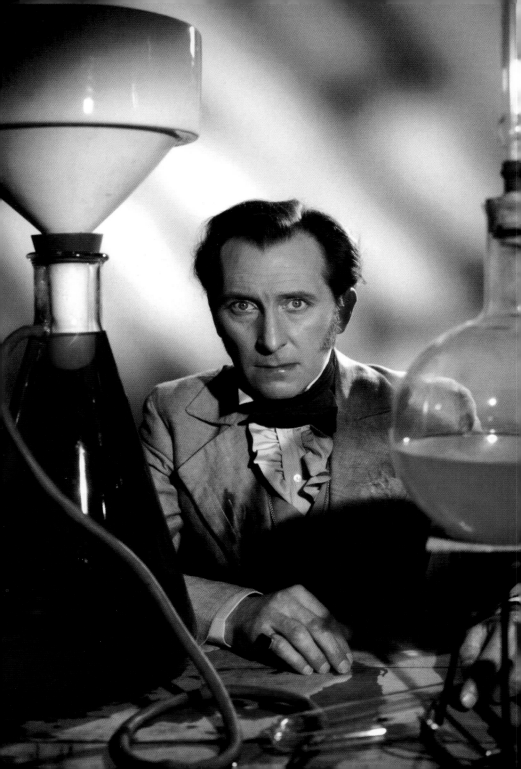

BRAY: HAMMER HORROR

HAMMER FILMS was founded as a film production company in 1934, but is best known for the long series of horror films that started to be produced in the 1950s. Hammer was founded by William Hinds, and he was joined by Enrique Carreras in 1934. The company produced five films before going bankrupt in 1937, but their distribution company, Exclusive Films, survived. In 1938 Enrique's son James joined Exclusive, and then William Hinds's son Anthony joined too. Unfortunately the Second World War started just when the company was becoming established.

Having been called up, the younger Carreras and Hinds did not return till 1946, but at that point they decided to relaunch Hammer Film Productions. With very little cash available, the company set about making a series of cheap 'quota quickies'. They initially used Marylebone Studios, but then realised that they could hire a stately home for far less money. At this time many of Britain's fine stately homes were being sold off by their impoverished aristocratic owners or falling into disrepair.

Hammer first rented Dial Close, near Cookham Dean, then moved to Oakley Court on the Thames near Windsor. This supremely Gothic-looking mansion would later be used as Frank N. Furter's mansion in *The Rocky Horror Picture Show*. In 1951 Hammer moved to another nearby mansion, Down Place. The house was in bad condition, and when the opportunity arose Hammer decided to buy the freehold and then convert it into their own studio. They renamed it Bray Studio and it was to remain the home of Hammer until 1966.

Hammer initially produced a mix of different types of film, with no concentration on any particular genre. However, the success of *The Quatermass Xperiment* in 1955 led Carreras and Hinds to concentrate investment on further horror films. Hammer made a further two science fiction horrors; then in 1956 Jimmy Sangster was hired to write a script that would eventually become *The Curse of Frankenstein*. They were keen to make the film very different from the classic Universal/James Whale adaptation and Hammer chose to make the film in vivid Eastmancolor.

Opposite:
Peter Cushing became a stalwart member of the regular Hammer film cast, and his role as Victor von Frankenstein was reprised in many sequels. In this publicity shot for *The Curse of Frankenstein*, Cushing's fraught expression, along with the florid colours and dramatic lighting, reflect the typical Hammer style.

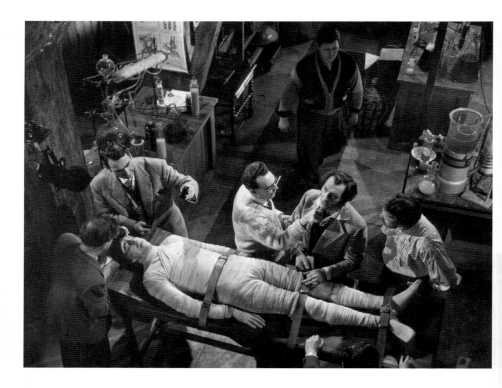

This wonderful production photo shows the setting up of a shot on the first Hammer Horror hit, *The Curse of Frankenstein* (1957).

The film was directed by Terence Fisher and starred Christopher Lee and Peter Cushing. This team was to make up the creative core of many successful Hammer films in the coming years.

The Curse of Frankenstein was the first British horror film to be shot in colour and it shocked the British Board of Film Classification (which rated it 'X') and contemporary critics. However, the British public loved it, and Hammer realised it was on to something. The company went almost directly into production on *Dracula*, again teaming director Fisher with Lee and Cushing in lead roles.

Carreras was a talented businessman and he would encourage interest in Hammer films by showing distributors a list of titles,

This 1958 poster for *Dracula* already displays many of the trademarks (the bright colours and glamorous female leads) for which Hammer would become known.

with colourful posters and clips of highlights of films that were not yet finished. He sold packages of films whereby, in order to distribute a likely hit, cinema chains also had to distribute a number of other, less flashy productions. By using these sales methods Carreras kept Hammer churning out film after film.

Hammer was also run on a very economical basis. The crew were paid relatively low wages for the time and the director and stars were often offered a percentage of the takings rather than a high up-front fee. The regular Hammer crew became adept at making films almost back to back, often with only minimal changes to sets, costume or even cast.

Christopher Neame, who worked at Bray as a young man in the camera department, remembers how the Hammer production designer, Bernard Robinson, achieved the set turn-around between *Dracula — Prince of Darkness* and *Rasputin* in just a weekend:

Considering the low budgets allocated to most Hammer productions, the Bray production designer, Bernard Robinson, did a wonderful job recreating Dracula's castle in this scene from *Dracula*, Christopher Lee's first outing in one of his most famous roles.

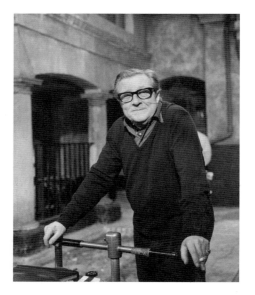

Terence Fisher was one of Hammer's most prolific directors, working on its films from the 1950s through to the 1970s.

Christopher Lee was Hammer's second leading man. He is particularly known for his overtly sensual interpretation of his oft-repeated role, Dracula.

The side walls were swivelled round, the bleak stonework now hidden as previously prepared gilt and pastel colours were revealed. A couple of panels were removed and now there were palace windows, with a well-painted canvas backing beyond. Imitation marble flooring made of paper was laid over *Dracula*'s painted grey flagstones. The sound of footsteps on marble would be added later.

At this time Bray was a very basic studio, certainly when compared to the purpose-built studios at Shepperton, Pinewood and Elstree. Down Place was extended to incorporate the dressing rooms, sound, camera and prop departments, and a restaurant. Bray had two small sound stages, and a useful exterior lot including 35 acres of mixed land. Hammer used the house as well as the sound stages in which to film, and despite a leaking roof managed to use the old dining room as a location for any sets they could not cram in elsewhere.

The reason that Hammer managed to get away with paying their crew low wages was because Bray was such a pleasant place to work. Carreras in particular was able to inspire loyalty among his cast and crew. Neame remembers: 'Many elements contributed to the unity, but the most important one was the complete faith and trust we had in our employers. They were all 100 per cent fair, and honest to a fault.'

Even Christopher Lee, who has sometimes resented the typecast roles his Hammer career forced on to him, recalls with

affection: 'Everyone was extremely friendly. The food was the best in England and the atmosphere in the studio was better than any other I've ever worked in … We all got on together very well. It was a very happy time; probably the happiest time of my career.'

There were even two studio cats. The crew was made up of technicians and craftsmen who had previously worked for the other British studios. They contributed to a Hammer Horror 'factory' that was efficient and professional. Many of the crew met their spouses at Bray and there were many members of the regular team who were related or married to each other. While original founder William Hinds was followed by his son Anthony, eventually three generations of the Carreras family worked in the business, Enrique, James and Michael.

Anthony Hinds was the son of one of the company's original founders, William Hinds. He worked with James Carreras to make Hammer an influential film company.

Investing further in horror films, Hammer over time – like Gainsborough and Ealing – became known as a single-genre studio. With a valuable style and a regular cast, 'Hammer Horror' rapidly became a familiar brand in its own right, eventually used in television series and even in a tie-in magazine.

Popular success in the United States enabled Hammer to negotiate distribution deals and funding with a series of different American film companies. In 1959 a deal with Universal gave Hammer carte blanche to remake any of the classic Universal horror films that had been made in the 1930s. Among the first few they chose was *The Mummy* (a remake of *The Mummy's Hand*), and it was made with the same creative team: Sangster, Fisher, Lee and Cushing. Rather than branching out into any new type of film, having hit on success, Hammer capitalised on its earlier films and many became film series. *The Curse of Frankenstein* had six sequels and Christopher Lee was to play Dracula in seven films (unfortunately of uneven quality).

For the cast and crew working at Bray, while the subject matter of the films was not hugely varied, they were working in a friendly home-like studio, with the prospect of long-term employment – something not to be sniffed at. Of his vital position as a horror film star at Hammer, Peter Cushing remarked (in a 1973 interview): 'I didn't set out to make this kind of picture, it just came my way. But it's been going on for me for sixteen years now and it's wonderful for an actor to work consistently. There seems to be an insatiable audience for this type of film.'

Although the Hammer name is synonymous with horror, the company did make other kinds of film, dabbling in *film noir* and psychological thrillers (these were mainly scripted by Hammer regular Jimmy Sangster). Unlike the horror films, these often featured a wider range of actors, including Americans, providing a contrast with the overtly British style of the Hammer Horrors.

In 1963 the Associated British Picture Corporation offered to become a joint owner of Bray Studios and in 1964 joined forces with Hammer and the American Columbia to become co-owners. The new deal guaranteed that Hammer would continue to control Bray, but ABPC's priority was maintaining production at Elstree; Hammer was therefore asked to consider Elstree studios before its own, using Bray only when Elstree could not fit them in.

The last Hammer production actually made at Bray was *The Mummy's Shroud*, which concluded filming on 21 October 1966. Fashions in horror

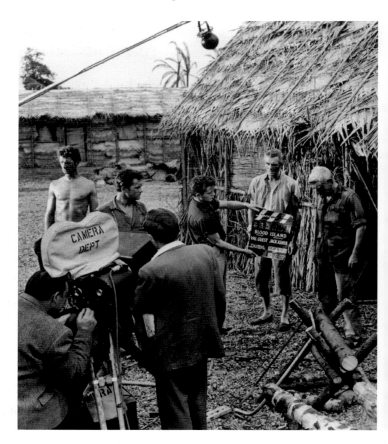

This production shot from *The Camp on Blood Island* (1958) shows that while Hammer was known for its Gothic look (often making use of rooms in the stately home at the centre of Bray Studio) they also made films with more diverse settings.

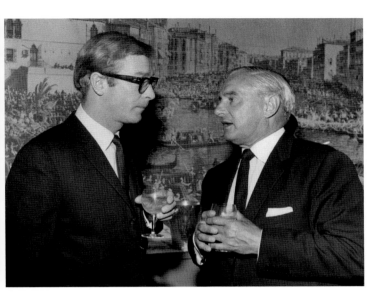

James Carreras (here with Michael Caine) was the son of Enrique Carreras, the co-founder of Hammer. Like Anthony Hinds, James joined the company in the late 1930s and he was to be succeeded by his own son, Michael Carreras.

Here the cast and crew of *Dick Turpin* assemble outside Stage 2 at Bray Studio in 1956.

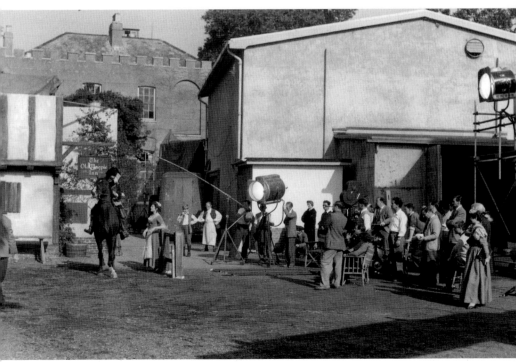

The Hound of the Baskervilles (1959) established Peter Cushing in another iconic role, this time as Sherlock Holmes.

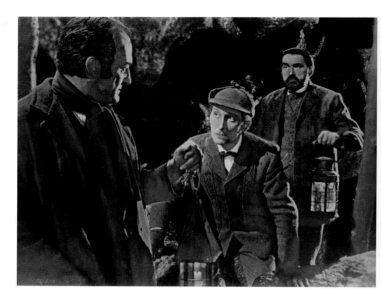

The Woman in Black (2012), starring Daniel Radcliffe, has marked a return to the horror genre for the newly reformed Hammer brand and it is likely this trend will continue.

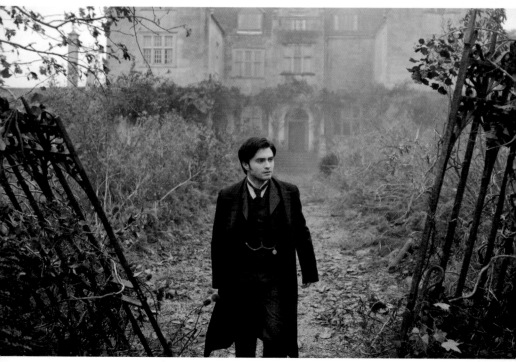

films were starting to change by the late 1960s, and the standard type of bloody, character-based films that had made Hammer's name was starting to fall out of fashion. In order to maintain sales, Hammer films started to feature more sexual content. Hammer completed a series of successful films in the 1970s, including the rather notorious 'Karnstein Trilogy', but the move away from Bray marked the start of a decline. Bray had existed not just as a set of stages, but as a real home to a consistent team of crew, writers, actors and directors. Even Down Place itself had contributed to the Hammer look, with many of the house's rooms used in the films shot at Bray over the years.

In 1968 Hammer was awarded the Queen's Award to Industry, in recognition of the contribution the company had made to British industry – but the award was made at Pinewood, not Bray, and by this point Hammer's strong sense of identity was already beginning to erode. In 1971 James Carreras retired and gradually other familiar members of the Hammer team also retired.

Following the sale in 1970, and despite numerous changes of ownership (including at one point the Samuelsons, grandsons of British film pioneer G.B. Samuelson), Bray has continued to be used as a studio. It has become

The Vampire Lovers (1970) was the first of the three films that became known as the 'Karnstein Trilogy' of vampire movies. This is a publicity shot of the film's star, Ingrid Pitt.

established as the place to shoot model work and special effects. In this capacity it has been used to produce special effects footage for films such as *Alien* and *The Imaginarium of Doctor Parnassus*.

Hammer continued to make films using a variety of other studios as a base, including Elstree and Pinewood, and even filming abroad. Hammer ceased making horror films in 1976, with *To the Devil a Daughter*, but the Hammer Horror brand was still potentially profitable. In the 1980s two popular 'Hammer Horror' television series were made – keeping the brand alive on the small screen. In 2007 a Dutch producer, John de Mol, bought Hammer, including a back catalogue of over three hundred old films. Hammer returned to film production in 2008 but really came back with a vengeance with the classic horror *The Woman in Black* (2012). The huge success of that film seems to have ensured that Hammer Horror is back in business and here to stay.

ONWARDS AND UPWARDS

IN THE DARK, snow-bound days of December 2010 the Harry Potter franchise was coming to an end, with re-shoots of the vital last scene, set at King's Cross station. Platform 9¾ had been built in its entirety inside an old leaking hangar in Leavesden studio. Buckets were placed strategically to catch drips of melting snow, and in the distance the sounds of destruction could be heard. This was the end of an era for everyone involved in the films, many of whom had been working at Leavesden since the Harry Potter films started ten years previously, but the demolition of the old studio buildings was by no means a bad thing. Warner Bros had decided to invest in building a new studio in the United Kingdom, and by 2011 the studio had been reborn as Warner Bros Studio, Leavesden. To understand the significance of this step, we need to look back over the history of Leavesden Studio.

In many ways the Warner Bros studio at Leavesden exemplifies the best of the British film industry in the twenty-first century. When studios such as Shepperton, Pinewood and Elstree were enjoying a 'golden age' of film-making, Leavesden was not yet a studio but a factory – built by Rolls-Royce and used to manufacture aircraft during the Second World War. The massive hangers stayed empty for decades before being rediscovered and converted into a basic studio for the Bond film *GoldenEye*, in 1995.

The James Bond franchise has historically been the backbone of production at Pinewood, but on this occasion there was not enough room to shoot everything at the home studio. The new studio facilities were then used for *Mortal Kombat: Annihilation* before becoming a base for early pre-production on the come-back Star Wars film, *The Phantom Menace*. Tim Burton arrived in 1999 to create his characteristically spooky *Sleepy Hollow* sets on the large back lot.

In 2001 Warner Bros were looking for a studio in which to make their new film, *Harry Potter and the Philosopher's Stone*. Although in 2000 Warner Bros did not know that they were embarking on what would become an eight-film franchise, the studio they had chosen was perfect for this long-term production schedule. It would have been impossible to take

over another studio and build huge semi-permanent sets (like the Great Hall) that could be left standing between films. They had the unique luxury of taking over the whole site and inhabiting it for a decade. By converting Leavesden, Bond had aided another hugely successful series of British films, the Harry Potter series.

The older film studios have now been working under a 'four wall' system for many decades. The days of contract crew and long-term employment have been replaced by an ever-changing picture of independent films, with their freelance crew coming in to use the facilities for a few weeks or months and then moving on. But Leavesden, one of the most recent studios, developed in very unusual circumstances. The constant occupation by Warner Bros, shooting eight Harry Potter films back to back, led to Leavesden developing far more like the studios of the 1930s or 1940s.

Crew hired for one film usually stayed on for many (if not all) of the sequels; the core cast remained the same, and even the core sets remained the same. This highly unusual stability and long-term employment enabled creative teams to learn on the job and develop new ideas, the whole crew eating together each day and working together on a single project. Many crew members came in at the lower levels of a technical department and worked their way up over the years. In order to create a magical world, departments grew and developed, exploring green screen technology,

Although the studio was not yet properly developed, Tim Burton made use of the Leavesden back lot to build his typically spooky sets for *Sleepy Hollow* (1999), which starred Johnny Depp (pictured).

CGI, model making and even animatronics in order to bring Quidditch, dragons and magical spells to life. The old apprenticeship system had been replicated, without ever being formally recognised as such.

David Heyman (producer) comments:

> The making of the Harry Potter films has been unique. On a normal film, cast and crew work together for thirty, sixty, sometimes one hundred days and then go their separate ways – but we have been together for ten years. We have seen marriages and births. I met my wife on the third film, we married on the fifth, and we had a baby boy on the sixth. There have also been divorces and deaths. Our child actors, who started as nine-, ten-, and eleven-year-olds, have sat for their end-of-school exams, and some have gone to university. In the meantime, many of those on the other side of the camera have gone through their own education, starting out in one job and moving onwards or upwards to some new skill, evolving, progressing, and taking on greater responsibilities.

The young cast of *Harry Potter and the Philosopher's Stone* (Rupert Grint, Emma Watson and Daniel Radcliffe) would grow up together on set; the crew that made the Harry Potter films also became something of a family.

The approach to set building for the Harry Potter series was quite unusual. Sets are usually built to exist for a short period of time, so although materials may look like marble or stone, for example, this is achieved using art department fakery. But the Harry Potter art department knew that the key sets would be required for many years. They needed to be durable as well as realistic. With this in mind, several key rooms in Hogwarts were built as permanent sets. This meant that in the Great Hall, for example, the furniture and panelling were solid wood, and a considerable proportion of the art department budget was spent laying a real flagstone floor. The set was built to last, and still stands in the new Warner Bros Studio Tour today.

At Leavesden the hangars converted to sound stages were enormous. The inside space of the studio was so vast that the cast and crew had their own bicycles to get around – Rupert Grint's was a bright pink BMX! In a modern studio, although there are still on-site cafés, visiting films usually arrive with their own catering crew. Leavesden, like the film studios of the past,

Director
Alfonso Cuarón
talks to
Daniel Radcliffe
and Gary Oldman
on the set of
*Harry Potter and
the Prisoner of
Azkaban* (2004).

had one huge canteen in which the whole cast and crew would eat together most days. Over the years this was decorated with large glass cases, one for each film, displaying the best costumes and props. In the Hogwarts classrooms, desks and benches became adorned with graffiti, the work of ten years' worth of mischievous child film extras. The crew too were immortalised, with many appearing as moving portraits on the Hogwarts grand staircase set.

In previous films, platform 9¾ had been filmed at London's St Pancras station. For the last film the important final scene was once again shot there, but with unsatisfactory results. The natural clamour of the real-life station had interfered with the filming of this key moment in the Harry Potter story. The decision was made to re-shoot, but this time recreating the station inside the studio. This was not a decision lightly taken. Both the 'muggle' and magical platforms had to be recreated, and the Hogwarts Express and an ordinary train had to be transported to the studio, then installed on their film set tracks. The fact that the film-makers felt a move to the studio was necessary, and that this amazing feat was achieved during one of the harshest snowy winters of recent years, shows how much a studio setting helps the film-makers to achieve what they want.

By the time of *Harry Potter and the Deathly Hallows – Part 2*, the tired old hangars were freezing cold and leaking. They were ripped down shortly after the film was completed. Warner Bros made the unusual decision to make a permanent base in the United Kingdom and the company bought the whole Leavesden site and has invested £100 million in rebuilding the studios there. Leavesden now claims to account for roughly a third of Britain's total film stage space.

Explaining the Warner Bros plan in *Broadcast* magazine, Barry Meyer, the chairman and chief executive, said:

> For eighty-six years, Warner Bros has been intrinsically involved in film production in the UK. Our purchase of Warner Bros Studios, Leavesden, and our multi-million-pound investment in creating a state-of-the-art, permanent UK film production base further demonstrates our long-term commitment to, and confidence in, the skills and creativity of the UK film industry.

The new development ripped down most of the old aircraft factory buildings and has replaced them with purpose-built sound stages. Leavesden has become the newest studio in the United Kingdom. By doing this, Warner Bros is the first Hollywood studio to invest in a new European production

A view of the reconstructed Warner Bros Studio at Leavesden. Many of the older buildings have been demolished and in their place Britain's newest studio has sprung up. (™and © 2013 Warner Bros Entertainment Inc. All rights reserved.)

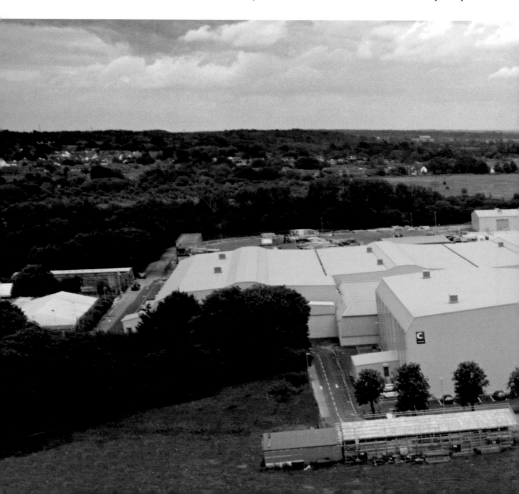

base since the 1940s. The gesture in itself harks back to the past and speaks of a confidence in British film production that is heartening for everyone involved in the industry.

This new 'Warner Bros Studios Leavesden' can rightfully be seen as a new studio for Britain. But without a Harry Potter-style film series to inhabit it, the studio is likely to run as a 'four walls' studio without the old-style camaraderie and continuous employment the old Leavesden established in its last decade.

While studios offering a range of film production services and facilities have always been and are still the standard in Britain, it is important to note that other kinds of studios have also featured in recent British film production.

Anyone driving through a certain stretch of rural Bedfordshire must have noticed two enormous hangars, standing in the middle of fields.

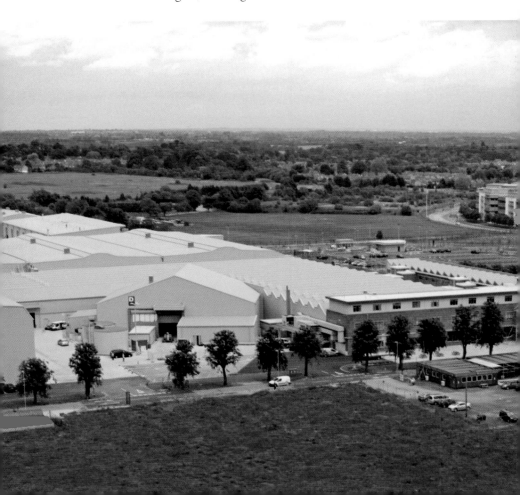

The two 'sheds' or hangars at Cardington were originally built as airship hangars during the First World War.

These are the Cardington hangars. The first was built in 1915 to be used for the construction of airships. After one of the airships crashed in 1930, all airship construction was halted. It was used again before the Second World War for the construction of barrage balloons but in the decades after that they were used for all manner of different purposes. The sheds were first used for filming on *Chitty Chitty Bang Bang* in 1968; then in 2004 Warner Bros were looking for locations for the new Batman film, *Batman Begins* (the first in Christopher Nolan's trilogy).

Christopher Nolan was keen to shoot in the United Kingdom, but he needed a location in which to build a large semi-permanent Gotham City set. The previous (Tim Burton) Batman films had built Gotham's streets on the back lot at Pinewood but Nolan wanted the control of an indoor, covered set. Cardington was perfect, and Shed 2 was filled with the full-scale Gotham set that would be used for all three Nolan Batman films.

Christopher Nolan filmed some scenes of his Batman films in conventional studios but also invested time and money building semi-permanent sets inside the huge sheds at Cardington.

The Gotham set was one of the largest indoor sets ever built and it enabled Nolan and his director of photography, Wally Pfister, to shoot as much as possible using real physical stunts (including flying with overhead wires) rather than relying on green screen or CGI effects.

In building Gotham City within the Cardington hangar,

By building his main Gotham City set at Cardington, Christopher Nolan was able to set up realistic flying stunts that would not otherwise have been possible.

Wally Pfister worked with the production designer Nathan Crowley to make sure that the Gotham set would be as flexible as possible for his anticipated filming needs. Interviewed for *American Cinematographer* magazine, Pfister explains:

Having made use of Cardington for his Batman films, Christopher Nolan chose to return there to film some scenes of his hit film *Inception* (2010). The Cardington scenes included the iconic revolving corridor seen below.

Very early on, Nathan built paper models of the city, and we sat there moving them around to figure out the ideal arrangement. I might say, 'Moving these buildings a little bit that way will give us a long, clear line of sight all the way down the street; I can put some light in the background and we'll have the most depth possible.' We also discussed what I needed inside the buildings. At first, the production didn't want to make some of the buildings structural because it was very expensive, but I really argued for it because we had to get electricians inside and on top of them. The studio eventually bit the bullet and paid to make those structures completely accessible.

Like the Harry Potter art department, the Batman art department pushed for semi-permanent sets that would stand up to a heavy schedule of filming on more than one film. Warner Bros also used the Cardington sheds for some filming on another Christopher Nolan film, *Inception*.

Longcross is another name that has cropped up just recently as a film studio. Unlike the more established studios, it offers stripped-down facilities and far fewer support services, but the availability of five large sound stages has made it a popular location for films, including *Captain America*, *Skyfall*, *War Horse* and *Clash of the Titans*. Longcross was originally a tank factory and test track.

In conclusion, the British film industry is healthier now than it has been for many decades in the past. The old studios continue to thrive, adapting to the changing demands of the industry – facilities built in the 1930s are still being used while technology constantly expands what it is possible to recreate on film. New investment and the conversion of other buildings have extended the number of sound stages available in the United Kingdom and it is likely that British film studios will continue to thrive long into the future.

Steven Spielberg's *War Horse* (made in 2011 with Tom Hiddleston, pictured) was mainly shot on location but also made use of stages and other facilities at Longcross, a former tank factory and testing track.

FURTHER INFORMATION

PLACES TO VISIT

The Cinema Bookshop, 13 Great Russell Street, Bloomsbury, London WC1B 3NH.
Telephone: 020 7637 0206.

The Hay Cinema Bookshop, Castle Street, Hay-on-Wye, via Hereford HR3 5DF.
Telephone: 01497 820071. Website: www.haycinemabookshop.co.uk

Imperial War Museum, Lambeth Road, London SE1 6HZ. Telephone: 020 7416 5000.
Website: www.iwm.org.uk

The London Film Museum is based on two sites: at Covent Garden (early photography and
the moving image), and at the South Bank (main collection).
LFM Covent Garden: 45 Wellington Street, Covent Garden, London WC2E 7BN.
Telephone: 020 3617 3010.
LFM South Bank: County Hall, Riverside Building, South Bank, SE1.
Telephone: 020 7202 7040. Website: www.londonfilmmuseum.com

National Media Museum, Bradford, West Yorkshire BD1 1NQ. Telephone: 0844 856 3797.
Website: www.nationalmediamuseum.org.uk

Tate Britain, Millbank, London SW1P 4RG. Telephone: 020 7887 8888.
Website: www.tate.org.uk/visit/tate-britain

Warner Bros Studio Tour, Aerodrome Way, Leavesden, Hertfordshire WD25 7LS.
Telephone: 08450 840 900. Website: www.wbstudiotour.co.uk

BOOKS

Barr, Charles. *Ealing Studios*. Cameron & Tayleur, 1980.

Drazin, Charles. *The Finest Years: The British Cinema of the 1940s*. I. B. Tauris & Co, 2007.

Low, Rachel. *Film Making in 1930s Britain*. George Allen & Unwin, 1985.

Meikle, Denis. *A History of Horrors: The Rise and Fall of the House of Hammer*. Scarecrow Press, 2008.

Owen, Gareth. *The Pinewood Story: The World's Most Famous Film Studio*. Reynolds & Hearn, 2006.

Owen, Gareth. *The Shepperton Story*. History Press, 2009.

Petrie, Duncan. *The British Cinematographer*. British Film Institute, 1996.

Warren, Patricia. *Elstree: The British Hollywood*. Elm Tree Books, 1983.

Warren, Patricia. *British Film Studios: An Illustrated History*. B.T. Batsford, 2001.

WEBSITES

Army Film and Photographic Unit: www.afpu.co.uk; *BAFTA*: www.bafta.org; *BECTU Oral History
Project*: www.bectuinterviews.uea.ac.uk; www.bectu.org.uk/advice-resources/history-project;
British Film Industry archive material: www.bfi.org.uk; *British Film Industry screenonline tours*:
www.screenonline.co.uk/tours; *British Movie Tours*: www.britmovietours.com; *British Society
of Cinematographers*: www.bscine.com; *The Elstree Project*: www.theelstreeproject.org; *Internet
Movie Database*: www.imdb.com; *History of the Gaumont film company*: www.gaumontbritish.com;
Lime Grove: www.bbctv-ap.co.uk

ACKNOWLEDGEMENTS

Thanks to my fantastic parents Brian and Simone, for bringing me up to believe that anything at all is possible; to Henry Lewes, who taught me to love films with tea at BAFTA and childhood visits to the Electric; and finally to my husband Sam, whose love and support inspire me every day of my life.

Also: Anne Runeckles (Pinewood), Frances Russell (BSC), Sue Malden (BECTU), Bob Redman and Paul Welsh (Elstree Screen Heritage), Marcus Hearn (Flashpoint), Paul Clark (AFPU), Kiran Shah, Lawrie Read and the inestimable Sir Sydney Samuelson.

Interview extracts have been included with the kind permission of BECTU (copyright of the BECTU History Project: www.bectu.org.uk/advice-resources/history-project) and the Elstree Project (www.TheElstreeProject.org), which is an ongoing oral history project, created in partnership between Howard Berry of the University of Hertfordshire and Bob Redman and Paul Welsh MBE of volunteer group Elstree Screen Heritage. The project has interviewed thirty veterans of Elstree Studios about their career in the film industry.

PICTURE CREDITS

I would like to thank The British Film Institute, Rex Pictures and Flashpoint Media for their help with the pictures in this book. Further details about the pictures are listed below – while every attempt has been made properly to attribute them, if any omissions or mistakes have been made, the Publisher will be pleased to rectify them on receipt of a written request. The numbers refer to page numbers and 't' or 'b' indicates use at top and bottom of pages, respectively.

American International Pictures, Hammer film productions and Fantale Films, 99; The Archers, 32b, 33; The Archers and Independent Directors, 4; The Archers, The Rank Organisation and Independent Directors, 35t; Associated British Picture Corporation, 80–1; British and Dominions Film Corporation, 10; British International Pictures, 12, 76, 79t/b; Brandywine Productions and Twentieth Century Fox Productions, 72; Carolco Pictures, JBS, Canal+ and RCS Video, 73b; P.G. Champion, 52; Cinegild, 34t, 36, 42t; Columbia Pictures Corporation and Hawk Films, 67; Columbia Pictures Corporation and Mirage, 73t; Danjaq and Eon Productions, 48; DreamWorks SKG, Reliance Entertainment, Amblin Entertainment and The Kennedy/Marshall Company, 108; Ealing Studios, 53, 54t; Gainsborough Pictures, 14, 20b, 21, 22–3, 24, 25t/b, 26, 27; Eon Productions, 47t; Grim23, 16; Eon Productions with Danjaq, MGM and United Artists, 47b; Gainsborough Pictures in association with Emelka and Bavaria Film, 4; Gainsborough Pictures and the Rank Organisation, 20; Gaumont-British Picture Corporation, 13, 18; G. B. Samuelson Productions, 9; Goodtimes Enterprises, 71; Hammer Film Productions, 1, 90, 92t/b, 93, 96, 97, 98; Hammer Film Productions, Alliance Films, UK Film Council, Talisman Productions, Exclusive Media Group, Film I Vast and Filmgate, 98b; Hepworth, 6b, 7t; J. Arthur Rank Organisation and Ealing Studios, 50, 55, 56t/b, 57, 58t/b; J. Arthur Rank Organisation and Group Films, 43; London Film Productions, 30b; Amanda Kerr-Munslow, 106t; London Film productions and British Lion Film Corporation, 65; Lucasfilm, 87t/b; MGM and Stanley Kubrick Productions, 83, 85; Paramount Film Service and Keep Films Co-Production, 70; Paramount Pictures, GK Films and Infinitum Nihil, 75; Paramount Pictures and Lucasfilm, 88t (both); Paramount Pictures, Mandalay Pictures, American Zoetrope, Karol Film Productions and Tim Burton Productions, 101; Peter Rogers Productions and Adder Productions, 44–5; The Rank Organisation, 42b; The Rank Organisation and Adder Productions, 46; Romulus Films and Warwick Film Productions, 68–9; TriStar Pictures, JBS, IndieProd Company Productions and American Zoetrope, 60; Twentieth Century Fox Films Ltd and Capitol Films, 17b; Twentieth Century-Fox, Dune Entertainment, Scott Free Productions and Brandywine Productions, 74t; Two Cities Films, 28, 34b; Warner Bros, 1492 Pictures, Heyday Films, 102; Warner Bros, 1492 Pictures, Heyday Films and P of A Productions Limited, 103; Warner Bros, Hawk Films, Peregrine and Producers Circle, 86; Warner Bros, Syncopy, DC Comics and Legendary Pictures, 106b, 107t; Warner Bros, Syncopy, Legendary Pictures, 74b, 107b; Weinstein Company, UK Film Council, Momentum Pictures (plus Aegis Film Fund, Molinare Investment, FilmNation Investment, See-Saw Films and Bedlam Productions), 89.

INDEX

Page numbers in italics refer to illustrations

2001: A Space Odyssey 82, 83, 84, 85, 86
Adam, Ken 67, 70
Alice in Wonderland 5, 6
Alien 72, 74, 99
Allen, Karen 88
Amalgamated (studio) 77
Amusement Tax 77
Andrews, Harry 80, 81
Army Film and Photographic Unit 39, 40, 41, 66
Associated British Picture Company 77, 78, 80, 81, 82, 83, 96
Associated Talking Pictures 11, 51, 52
Atlantic 12, 76, 77, 78
Attenborough, Richard 41, 66, 73
Bach, Barbara 48
BAFTA 43, 70, 75, 109
Baker, Kenny 87
Balcon, Michael 13, 15, 16, 18, 29, 51, 58, 59, 59, 70, 71
Bale, Christian 74
Barker, Will 11, 51
Barr, Charles 56
Batman (Burton film) 106
Batman (Nolan film series) 74, 107, 108
Becket 70
Blackmail 11, 13, 32, 78, 79,79
Bogarde, Dirk 43, 43
Bond, James 46, 47, 49, 67, 100, 101
Boulting, John 41, 64, 65, 66
Boulting, Roy 41, 64, 65, 66
Box, Betty 27, 43
Box, Muriel 27, 27
Box, Sydney 26, 29
Branagh, Kenneth 60, 61, 73
Bray 8, 37, 90–9
Brent Walker (Elstree) 78, 89
Brief Encounter 35
British and Dominions 78, 82
British Board of Film Classification 92
British Film Institute 59

British International Pictures 13, 31, 77, 77, 78
British Lion 59, 62, 64, 65, 70, 71
Broccoli, Albert R. 46, 48, 49
Brosnan, Pierce 47
Burton, Richard 46, 70
Burton, Tim 101, 106
Bushey Studio 7
Butterfield, Asa 75
Caine, Michael 97
Calvert, Phyllis 24, 25
Camp on Blood Island 96
Campbell, Judy 40
Cardiff, Jack 41,33
Cardington 106, 106, 107, 107
Carreras, Enrique 91,94, 95, 97
Carreras, James 91, 92, 93, 94, 95, 97, 99
Carreras, Michael 94, 95, 97
Carroll, Madeleine 18, 76, 77
Carry on Cleo 43, 44, 45
Carry On Doctor 46
Carry On series 58
Carry on up the Jungle cover
Cavalcanti, Alberto 51
Chaplin (film) 73
Chrichton, Charles 57
Cinematograph Acts 9, 10, 15, 27, 29, 61, 72
Clapham Road Studio 11
Cleopatra 43, 46
Clockwork Orange, A 84
Collins, Joan 43
Columbia Pictures 67, 96
Connery, Sean 46, 47
Corfield, John 37
Cricklewood studio 7
Crowley, Nathan 107
Crown Film Unit 39, 51
Cuarón, Alfonso 103
Curse of Frankenstein, The 90, 91, 92, 92, 95
Cushing, Peter 90, 91, 92, 95, 98
Cutts Graham 16, 59
Danziger studio 78, 82
Dark Crystal, The 88
Davies, John Howard 36
Davis, John 41, 65
Davy 53
Dean, Basil 11, 51, 57
Dearden, Basil 66
Denham 28–35

Depp, Johnny 101
Dick Turpin 97
Disney 35, 67
Doctor in the House 43
Donat, Robert 18
Down Place 91, 94, 99
Downey Jnr, Robert 73
Dr No 46, 47
Dr Strangelove 53, 67
Dracula 92, 92, 93
Dracula – Prince of Darkness 93
Dyall, Franklin 76, 77
Eady Levy 66, 72
Ealing 8, 11, 22, 24, 37, 50–9, 95
Easy Virtue 14, 15
Elstree 11, 12, 13, 37, 38, 48, 53, 67, 76–89, 94, 96, 99, 100
Elstree Screen Heritage 89
EMI 77, 78, 82, 86, 87, 88
Empire Strikes Back, The 86
Famous Players-Lasky 15, 16
Fanny by Gaslight 21, 24
Fields, Gracie 51, 52
Firth, Colin 89
Fisher, Terence 92, 94, 95
Ford, Harrison 88
Forde, Walter 19
Formby, George 51, 52, 53
Frankenstein 60, 61, 73
Friese-Green, William 8
Gainsborough (studio) 5, 14–27, 43, 51, 57, 58, 59, 95
Gate Studio 78
Ghost Train, The 19
Ghoul, The 13
Gielgud, John 17
Gilliat, Sidney 65
Grade, Michael 49
Granger, Stewart 24, 25, 25
Grant, Cary 35
Great Expectations 17, 34, 36
Green, Danny 58
Grey, Sally 40
Grint, Rupert 102, 102
Guinness, Alec 50, 51, 53, 56, 57
Haldane, Bert 51
Hamer, Robert 55, 57
Hamlet 28, 29
Hammer (Horror) 4, 24, 57, 90–9
Harry Potter 100, 101, 102, 103, 105, 108
Hawtrey, Charles 58
Hay, Will 51, 53

Hays Commission 23, 24
Heatherden Hall 37, 38, 43
Henson, Jim 88
Hepburn, Audrey 56, 56, 58
Hepworth, Cecil 5, 6, 6, 7, 109
Heyman, David 102
Hiddleston, Tom 108
Hinds, Anthony 91, 95, 97
Hinds, William 91, 95
Hitchcock, Alfred 4, 5, 11, 15, 16, 17, 18, 32, 59, 78, 79, 79
Hitchcock, Alma 4, 5, 17
Hobson, Valerie 40
Holloway, Stanley 50, 51, 55, 57
Hollywood 5, 9, 11,18, 23, 24, 31, 38, 43, 53, 59, 64, 77, 86, 89, 104, 111
Hooper, Tom 89
Hound of the Baskervilles, The 98
Howerd, Frankie *cover*, 46, 58
Hugo 75
Hunter, Kim 32
Huntley, Raymond 57
Hurst, Brian Desmond 30
Hyde Park on Hudson 89
Ice Cold in Alex 80, 81, 82
In Which We Serve 34, 35
Inception 107, 108
Indiana Jones 84, 86, 87
Indiana Jones and the Kingdom of the Crystal Skull 88
Irvine, Robin 14, 15
Jagger, Mick 71, 71
James, Sid 46, *cover*
Jassy 26, 26
Jeans, Isabel 14, 15
John, Rosamund 40
Karloff, Boris 13
Karnstein Trilogy 99, 99
Kent, Jean 40
Kerr, Deborah 35
Kind Hearts and Coronets 53, 53, 57
King's Speech, The 89, 89
Kingsley, David 65
Korda, Alexander 29, 30, 31, 32, 33, 35, 37, 62, 64
Korda, Vincent 29, 30
Korda, Zoltan 29,
Kubrick, Stanley 67, 70, 83, 84, 85, 86, 88
Ladykillers, The 53, 57, 58
Launder, Frank 65

Lavender Hill Mob, The 50, 51, 53, 56, 58
Lean, David 16, *17*, 35, 36, 37, 41, 42, 64, 71, 72
Leavesden 100, 101, 103, 104, 105
Lee, Christopher 43, *43*, *92*, *93*, *94*, 94, 95
Life and Death of Colonel Blimp, The 33, 35
Lime Grove *6*, 15, 16, 18, 19, 26, 27, 38
Littleton Park House 61, *63*
Lockwood, Margaret 15, *23*, 23, 24, *25*
Lodger, The 16
Lolita 67, 84
Lom, Herbert *57*, 58
London Films 30, 31, 32
Longcross 108
Loudon, Norman 61, 63, 71
Love Lottery, The 53
Love Story 21, *25*
Lucas, George 84, 86
MacKendrick, Alexander *57*, *58*
Madonna of the Seven Moons 21
Maggie, The 53
Magnet, The 53
Man in Grey, The *20*, 21
Man in the White Suit, The 53, 56
Marylebone Studio 91
Mason, James 15, 20, 21, *22–3*
Matter of Life and Death, A *32*, *33*, 33
Maxwell, John 78, 82
Meet Mr Lucifer 53
Meyer, Barry 104
MGM 18, 35, 59, 77, 78, 82, 83, 84, 86
Miles, Bernard *34*, 35
Mills, John *34*, 35, *80*, *81*
Moore, Roger *48*
More, Kenneth *42*, 43
Moretz, Chloe *75*
Morris, Ossie *36*, *42*, 71
Mountain Eagle, The *4*, 5, 18
Mummy, The 4, 95
Mummy's Shroud, The *1*, 96
Murray, Barbara 55
Nash, Percy 77
National Film Finance Company 64, 65, 70

Neame, Christopher 93, 94
Neptune Studio 77, 78
Nettlefold Studio 6
Nicholson, Jack 86
Night to Remember, A *42*
Niven, David *32*
Nolan, Christopher *74*, *106*, 107, 108
O'Toole, Peter 70
Oldman, Gary 103
Oliver Twist *36*, 37, 41, *42*, 71
Oliver! 66, *68*, *69*, 70
Olivier, Laurence *28*, 29
Ostrer Mark 15
Ostrer, Isidore 15, 24
Ostrer, Maurice 15, 19, 20, *20*, 26
Paramount 29
Passport to Pimlico 53, *55*, 55
Paul, Robert W. 6
Performance 71
Pfister, Wally 106, 107
Pinewood 8, 31, 33, 36–49, 64, 65, 84, 94, 99, 100, 106
Pink Panther, The 57, 58, 66
Pitt, Ingrid 99
Pleasure Garden, The 18
Powell, Michael *32*, 32, 33, 41, 64
Pressburger, Emeric *32*, 32, 33, 41, 64
Private Life of Henry VIII, The 29, *30*, 30
Prometheus 74
Quatermass and the Pit 82
Quatermass Xperiment, The 91
Quayle, Anthony *80*, *81*
Radcliffe, Daniel *98*, *102*, *103*
Raiders of the Lost Ark 86, 88
Rank (organisation) 26, 33, 35, 38, 41, 49, 53
Rank Charm School 43
Rank, J. Arthur 19, *22*, 27, 31, 32, 37, *40*, 49, 52, 64, 78
Red Shoes, The 33, 41
Reed, Carol 64, 65, 70
Renaissance Films 61, 73
Rescued by Rover 6
Return of the Jedi 86, *87*
Reynolds, Norman 87
Riverside Studios 26
Robinson, Bernard 93

Roc, Patricia 24, 25, *40*
Rock (studio) 78
Rocky Horror Picture Show, The 91
Royal Air Force Film Production Unit 39, 40, 41, 66
Run for Your Money, A 53
Russell, Ken 86
Rutherford, Margaret 55
Samuelson, G. B. 'Bertie' 8, 51, 99
Samuelson, Sydney 8, 9
Sangster, Jimmy 91, 95, 96
Saville, Victor 59, 29
Scorsese, Martin *75*, 75
Scott, Ridley *72*, 72, *74*, 74
Sellers, Peter 53, *57*, *58*, 58, 66, 67, 70
Sense and Sensibility 73
Shah, Kiran 88
Shearer, Moira *41*, 41
Shepperton 8, 35, 37, 41, 43, 49, 59, 60–75, 84, 89, 94, 100
Sherlock Holmes 8, 48, 98
Shining, The 84, *86*, 86
Sim, Alastair 57
Simmons, Jean *40*
Sims, Joan *44*, *45*
Sixty Years a Queen 8, 51
Skyfall 46, 48, 108
Sleepy Hollow 100, *101*
Slocombe, Douglas *56*, 87, 88
Smith, George Albert 7
Sound City 61, 62
Spielberg, Steven 84, 86, 87
Spy in Black, The 32
Spy Who Loved Me, The *48*, 49
Star Wars 84, 86, 88
Stoll, Oswald 7
Study in Scarlet, A *8*, 8
Syms, Sylvia *80*, *81*
Tate, Reginald 25
Taylor, Elizabeth 43, 46, 70
Temple of Doom, The 88
Terry-Thomas 66
The 39 Steps 18
The Archers 32, 33, 64
They Were Sisters 21
Thief of Bagdad, The 33
Third Man, The 64, *65*
Thomas, Gerald *cover*, 43
Thomas, Ralph 43

Thompson, Emma *73*
Titfield Thunderbolt, The 53
UFA (studio) 32
United Artists 30
Universal Pictures 91, 95
Valentino 86
Vampire Lovers, The 99
Victory Motion Pictures 59
War Horse *108*, 108
Warner Bros 82, 100, 101, 103, 104, 105, 106
Warner Bros Studio, Leavesden 100, *104*, 105
Watson, Emma *102*
Weaver, Sigourney *72*
Welles, Orson 64, *65*
Went the Day Well 51
Whale, James 91
Whisky Galore! 53, *54*
Whitehall Studio 11, 77, 89
Who Done It? 53
Wicked Lady, The *20*, *21*, *22*, *23*, 23
Wilcox, Herbert 77, 82
Williams, Kenneth *44*, *45*, 46
Williamson, James 7, 29
Winslet, Kate *73*
Woman in Black, The *98*, 99
Working Title 75
Worton Hall (studio) 8, 51, 62, 64
Young, Freddie *10*
Young, Robert *17*
Yule, Lady Annie 37